This Book Belong's To

To

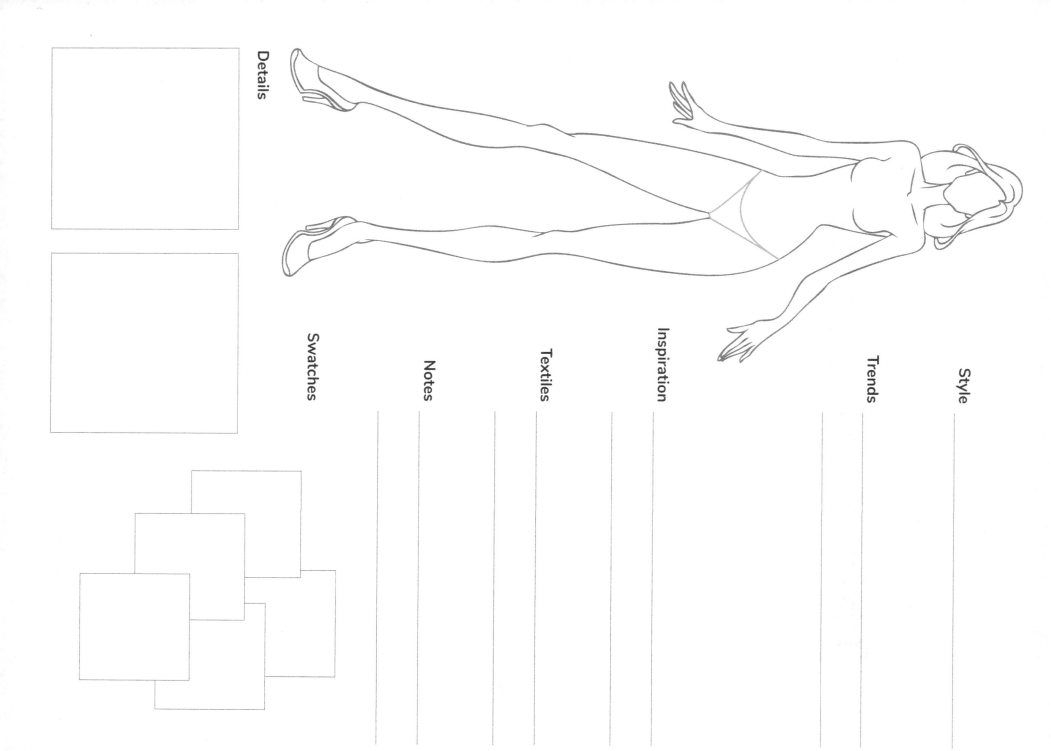

Details

Style

Trends

Inspiration

Textiles

Notes

Swatches

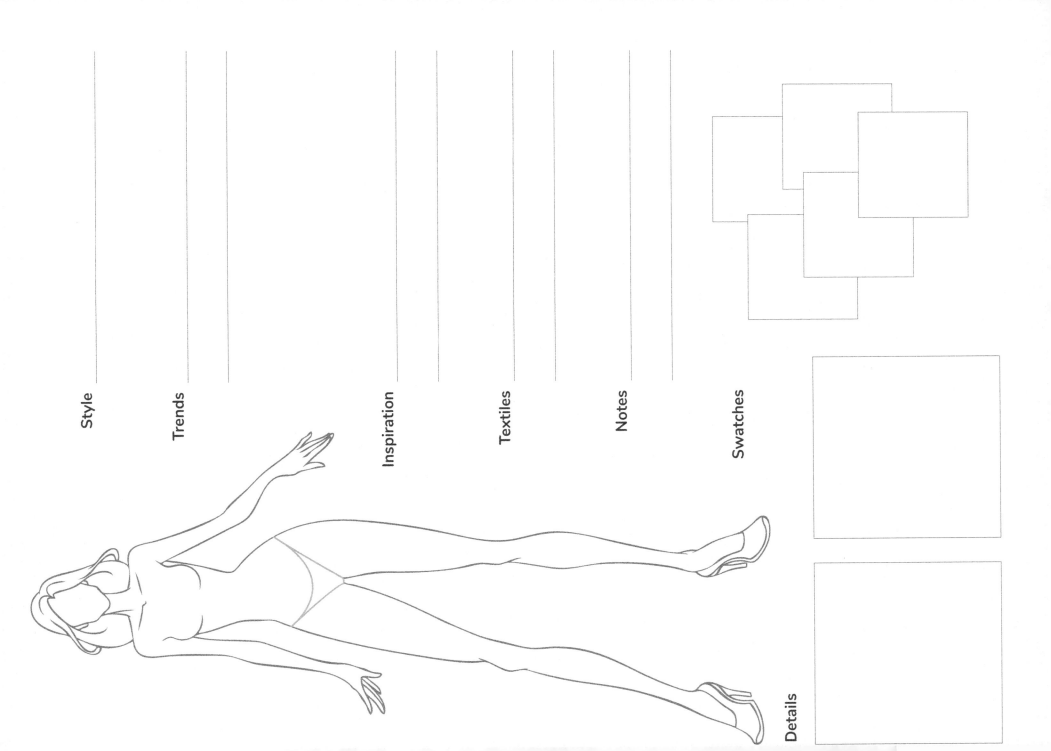

Style

Trends

Inspiration

Textiles

Notes

Swatches

Details

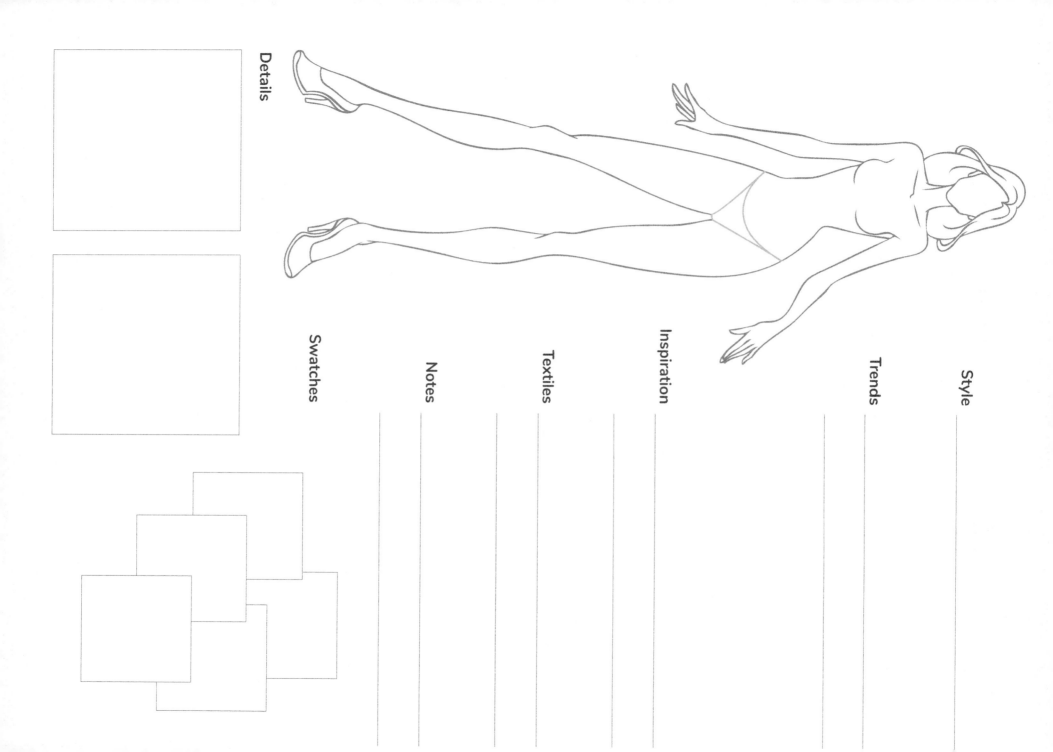

Details

Style

Trends

Inspiration

Textiles

Notes

Swatches

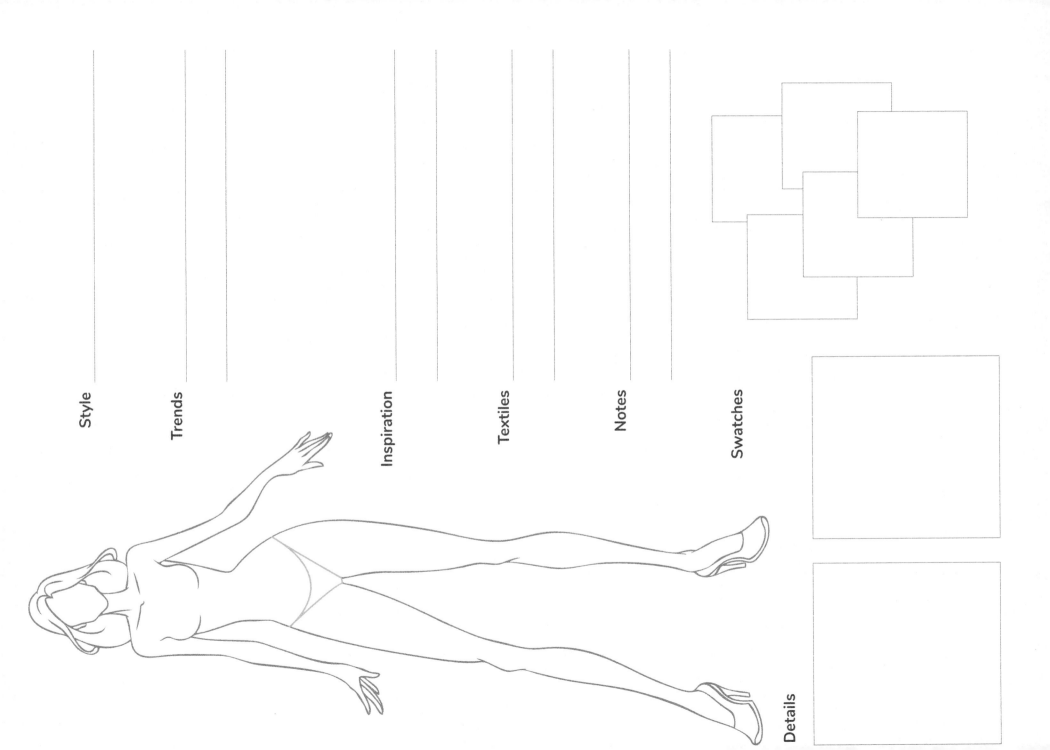

Style

Trends

Inspiration

Textiles

Notes

Swatches

Details

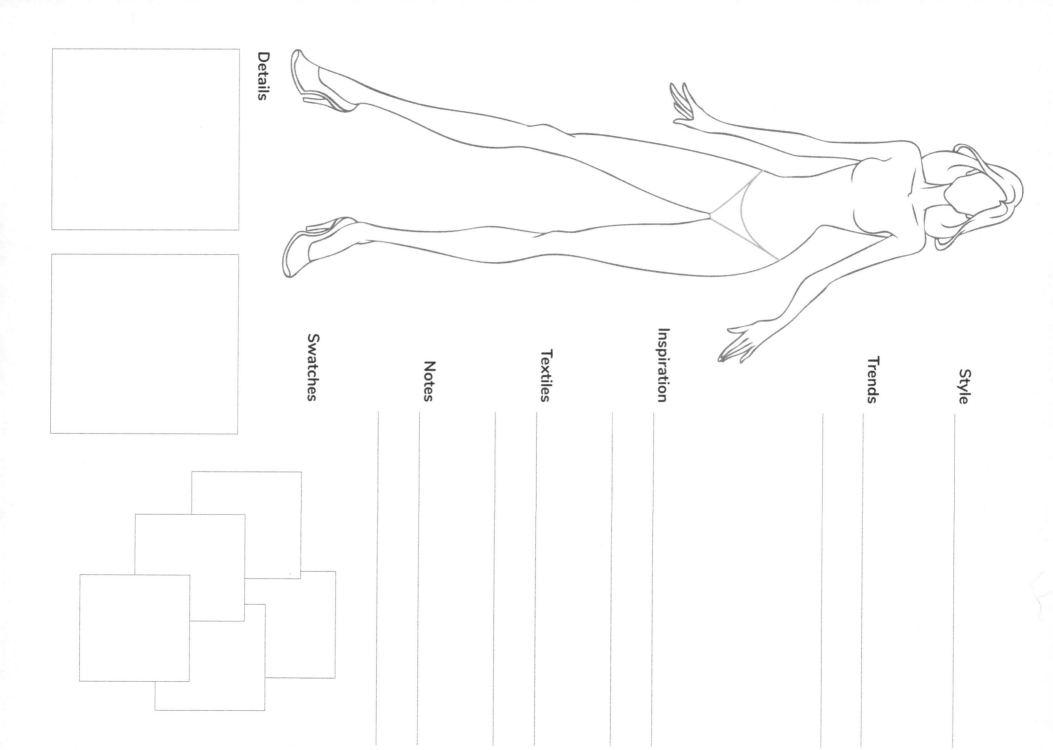

Details

Style

Trends

Inspiration

Textiles

Notes

Swatches

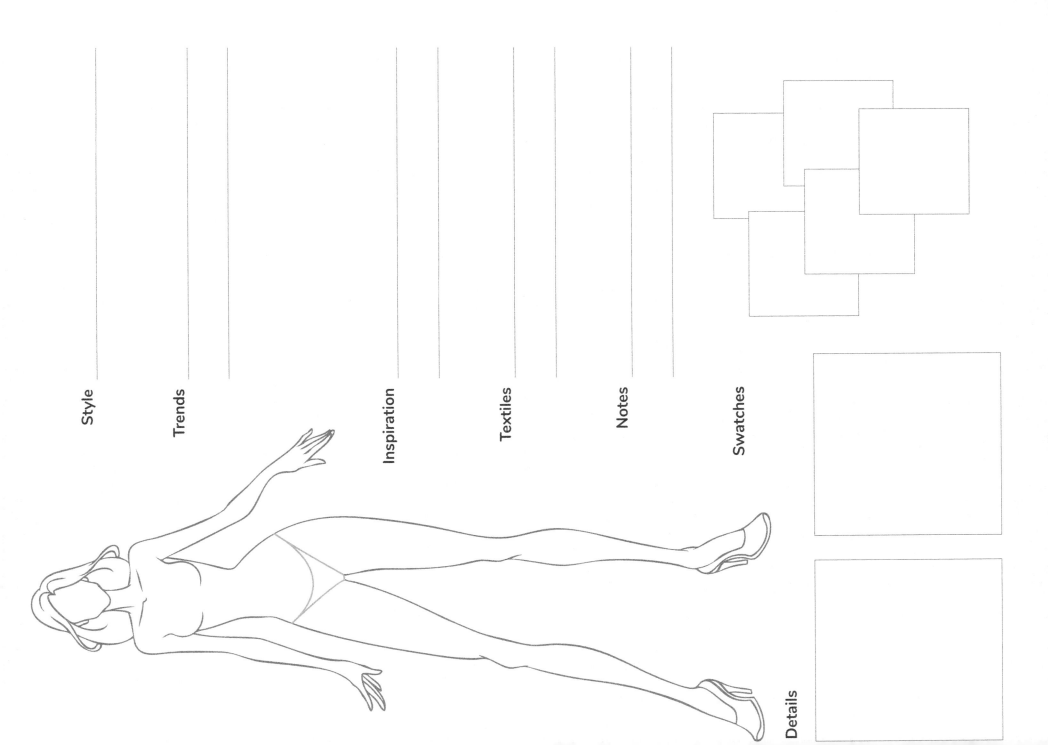

Style

Trends

Inspiration

Textiles

Notes

Swatches

Details

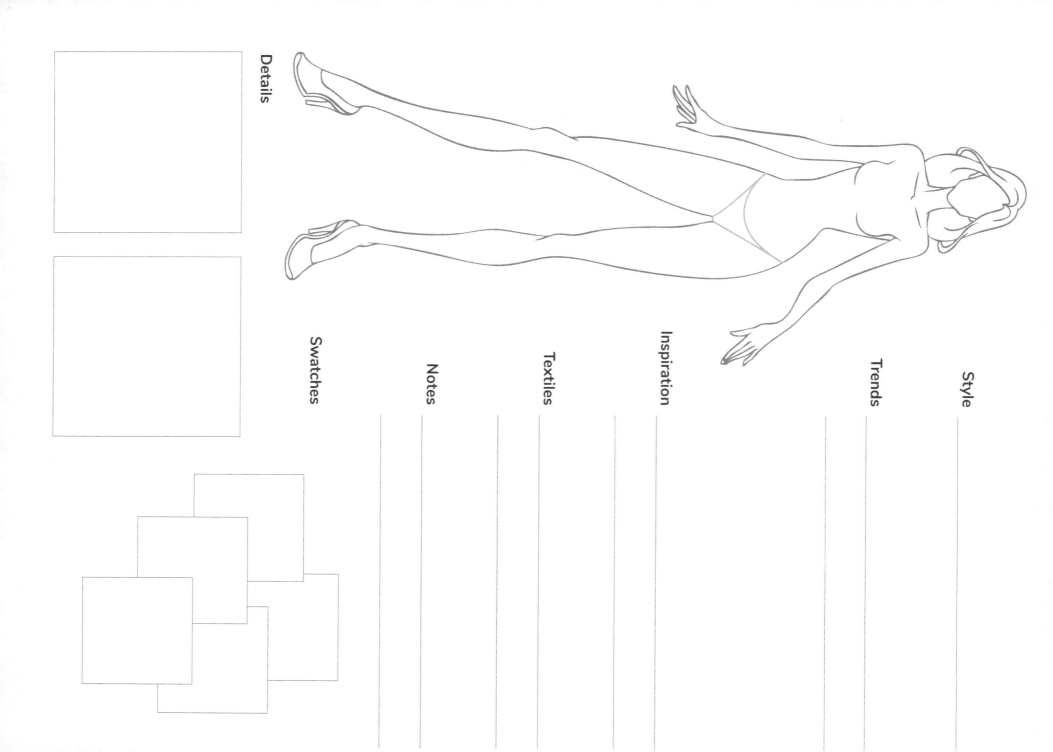

Details

Style

Trends

Inspiration

Textiles

Notes

Swatches

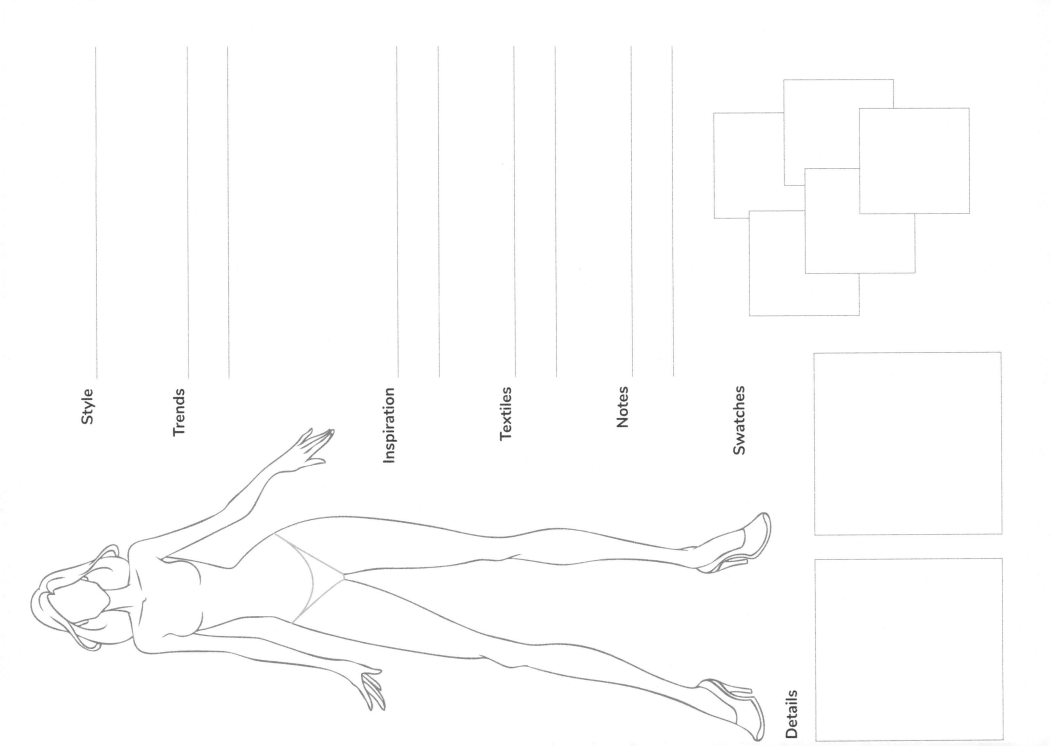

Style

Trends

Inspiration

Textiles

Notes

Swatches

Details

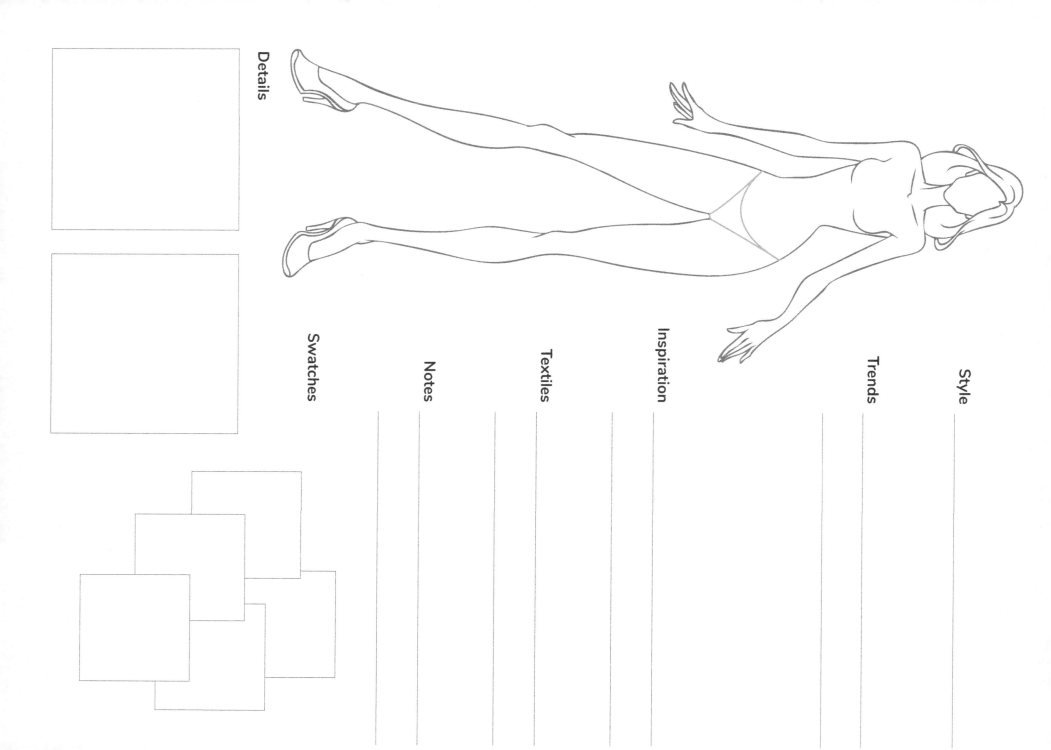

Details

Style

Trends

Inspiration

Textiles

Notes

Swatches

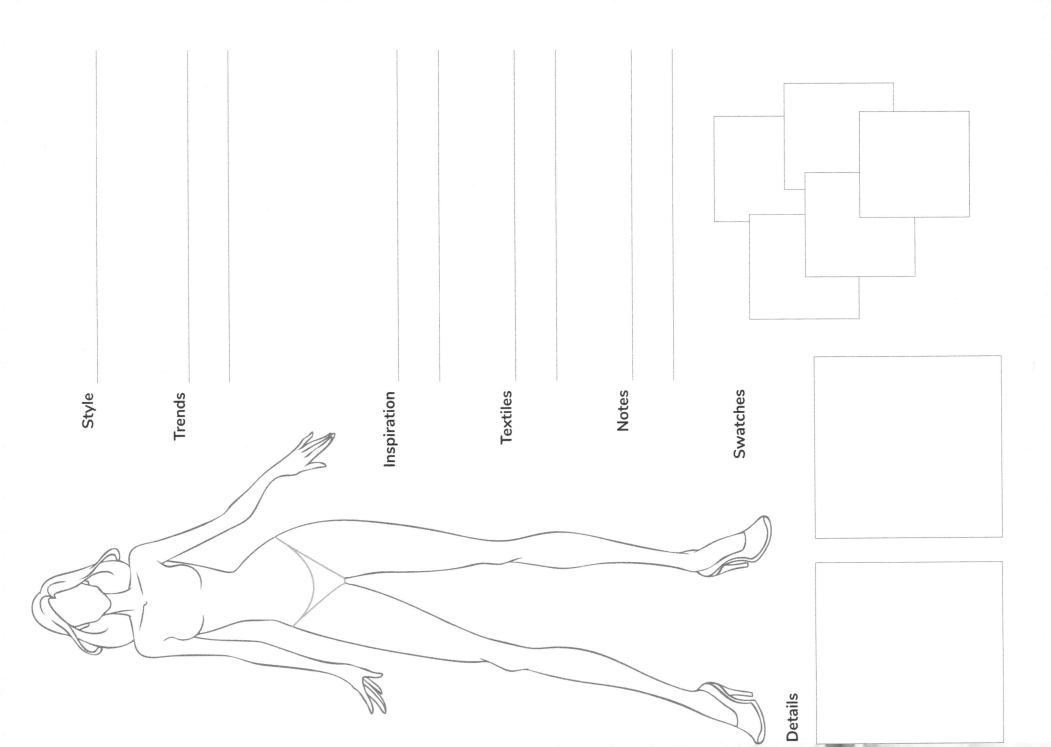

Style

Trends

Inspiration

Textiles

Notes

Swatches

Details

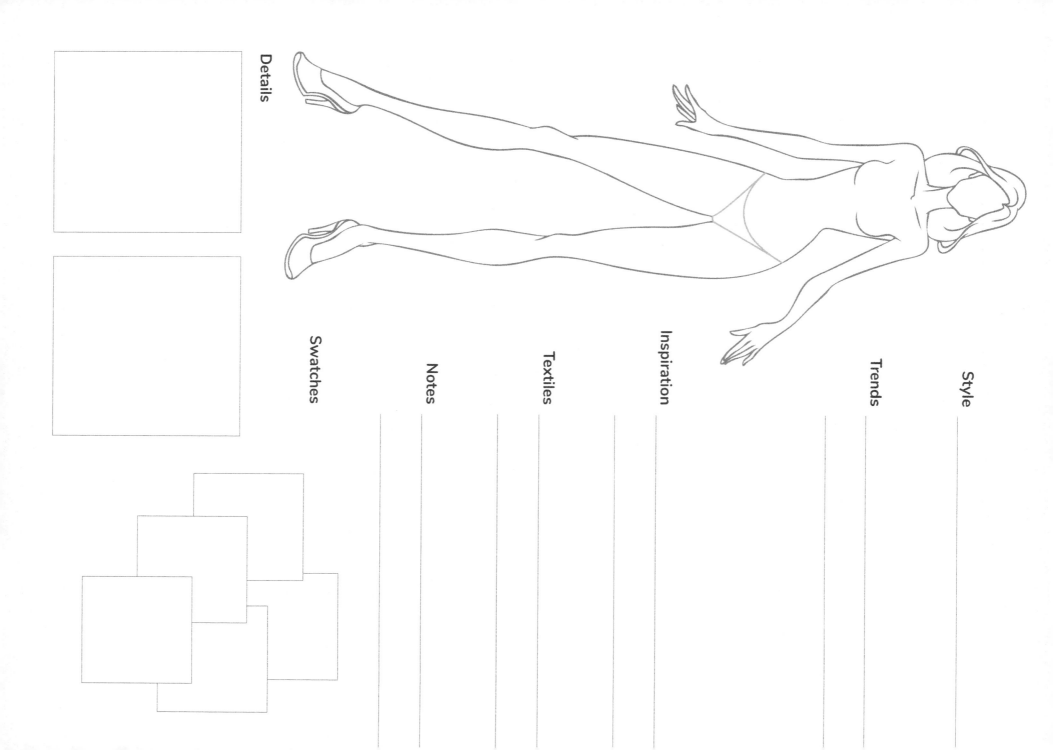

Details

Style

Trends

Inspiration

Textiles

Notes

Swatches

Style

Trends

Inspiration

Textiles

Notes

Swatches

Details

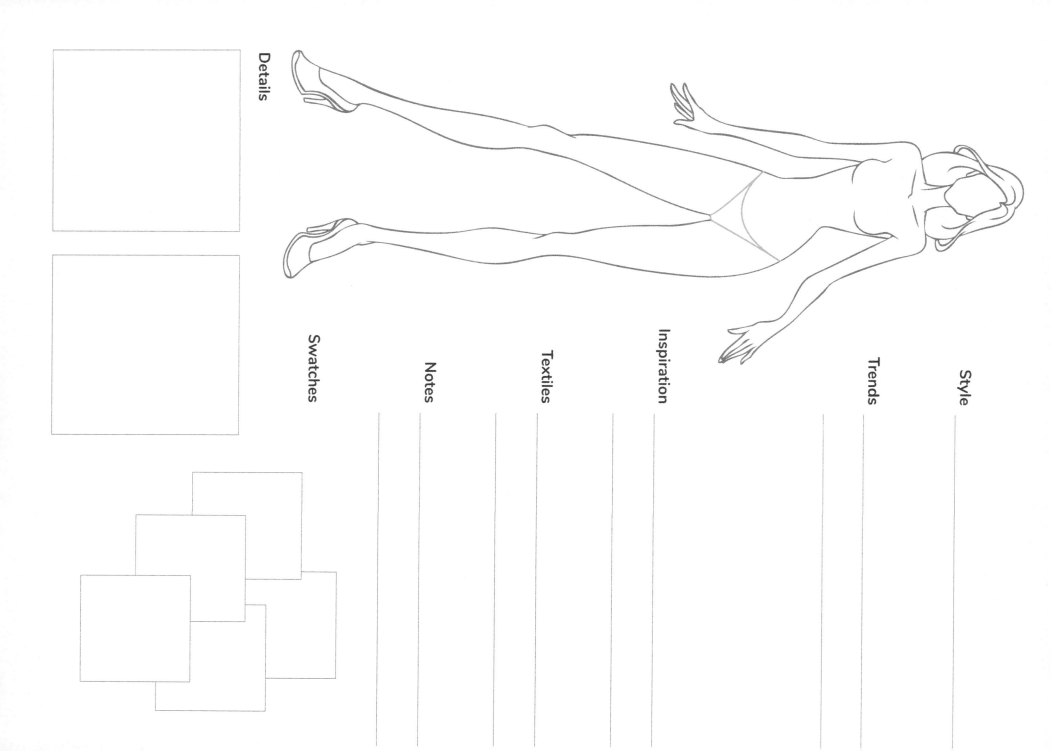

Details

Style

Swatches

Notes

Textiles

Inspiration

Trends

Style

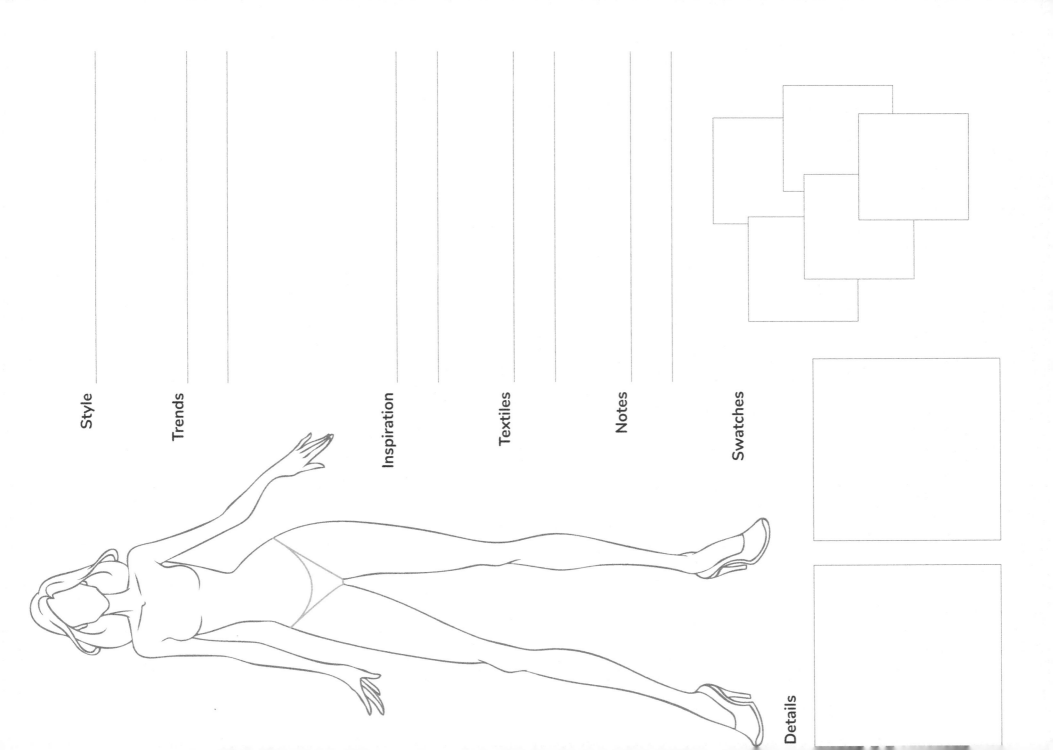

Style

Trends

Inspiration

Textiles

Notes

Swatches

Details

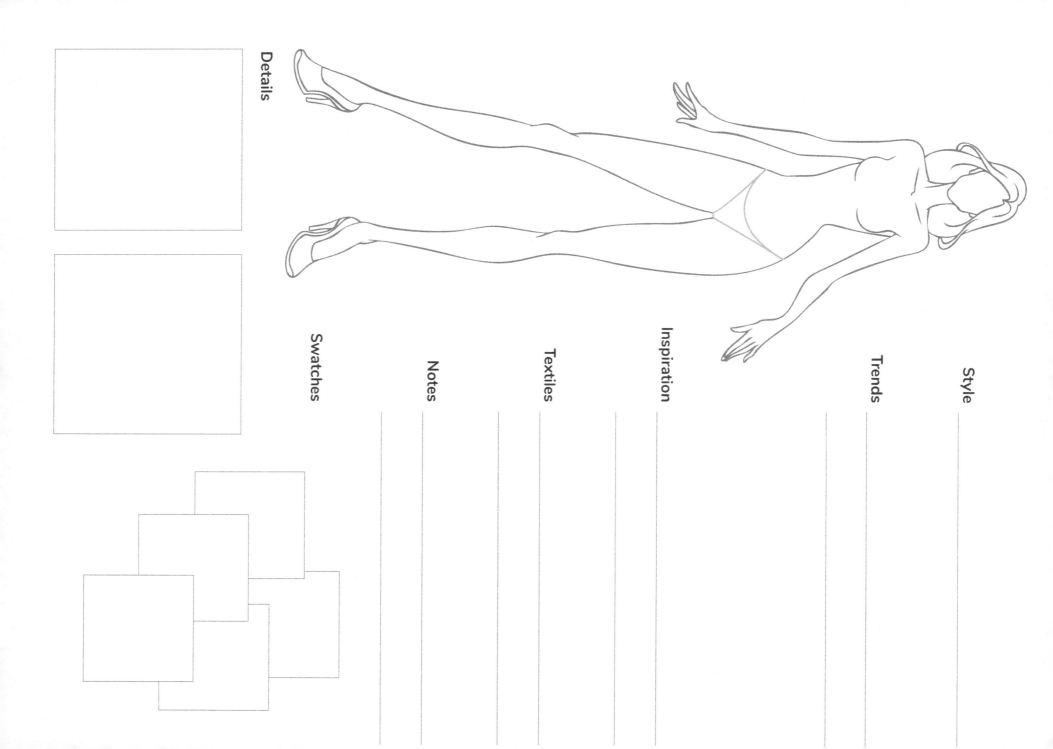

Details

Style

Trends

Inspiration

Textiles

Notes

Swatches

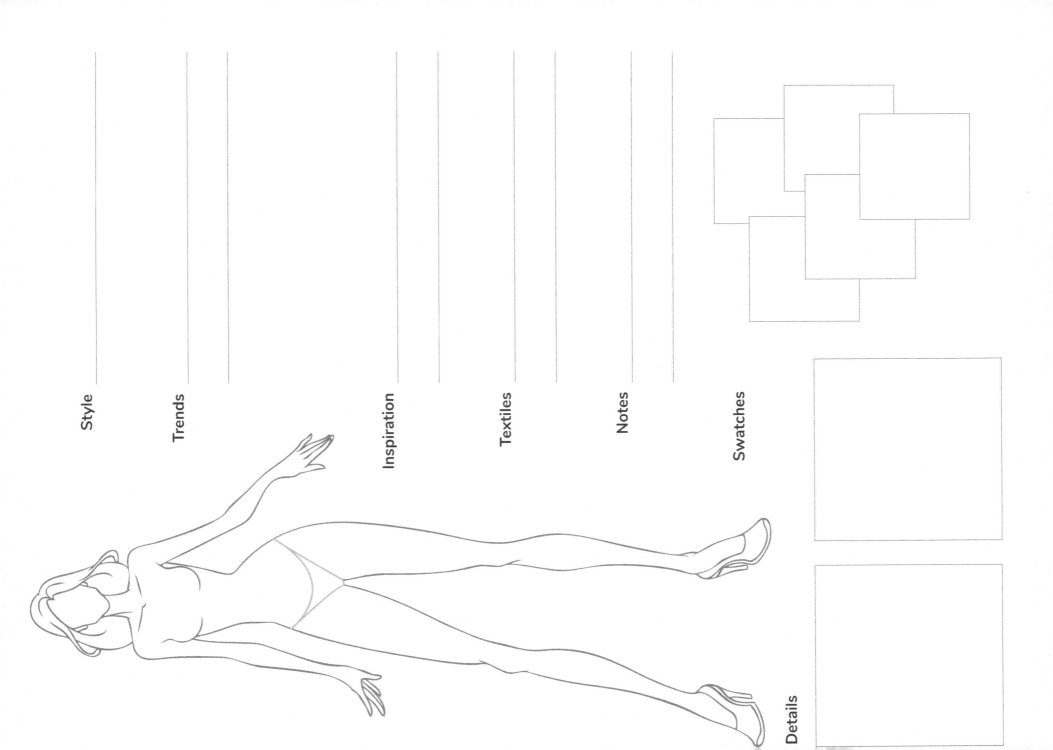

Style

Trends

Inspiration

Textiles

Notes

Swatches

Details

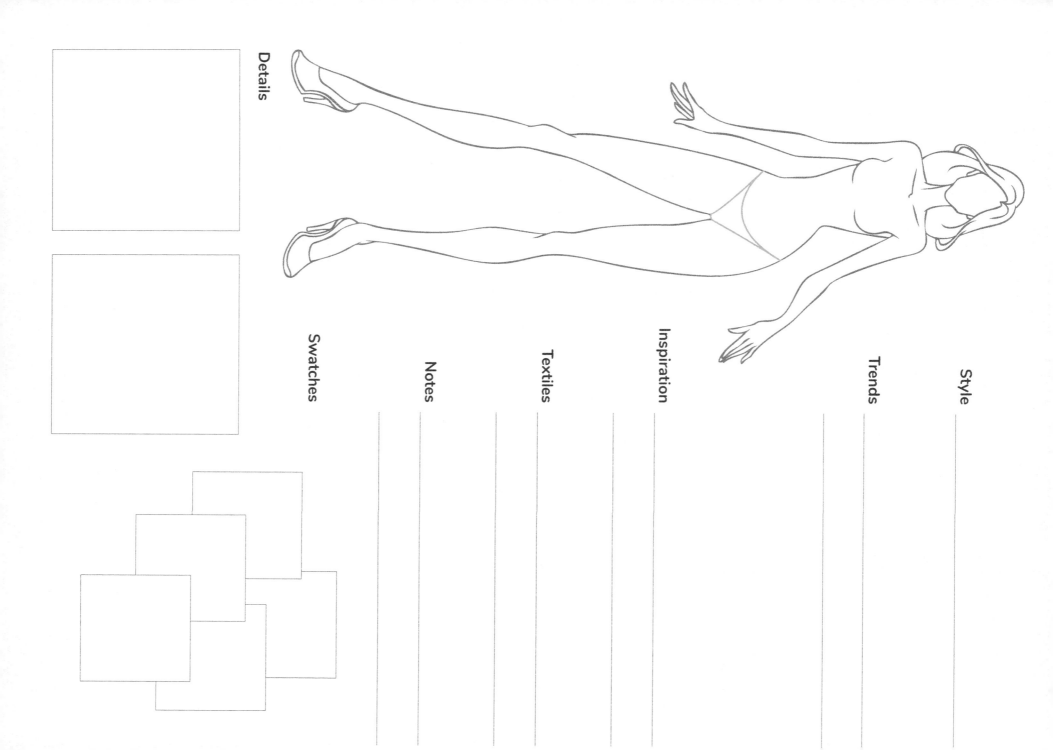

Details

Style

Swatches

Notes

Textiles

Inspiration

Trends

Style

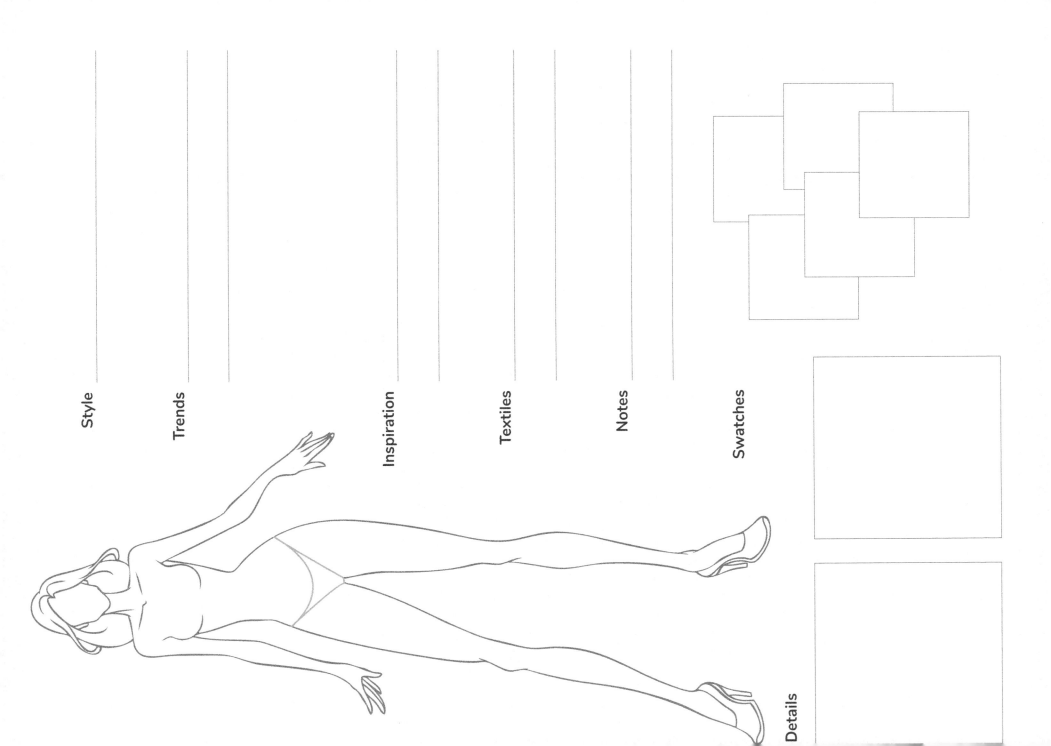

Style

Trends

Inspiration

Textiles

Notes

Swatches

Details

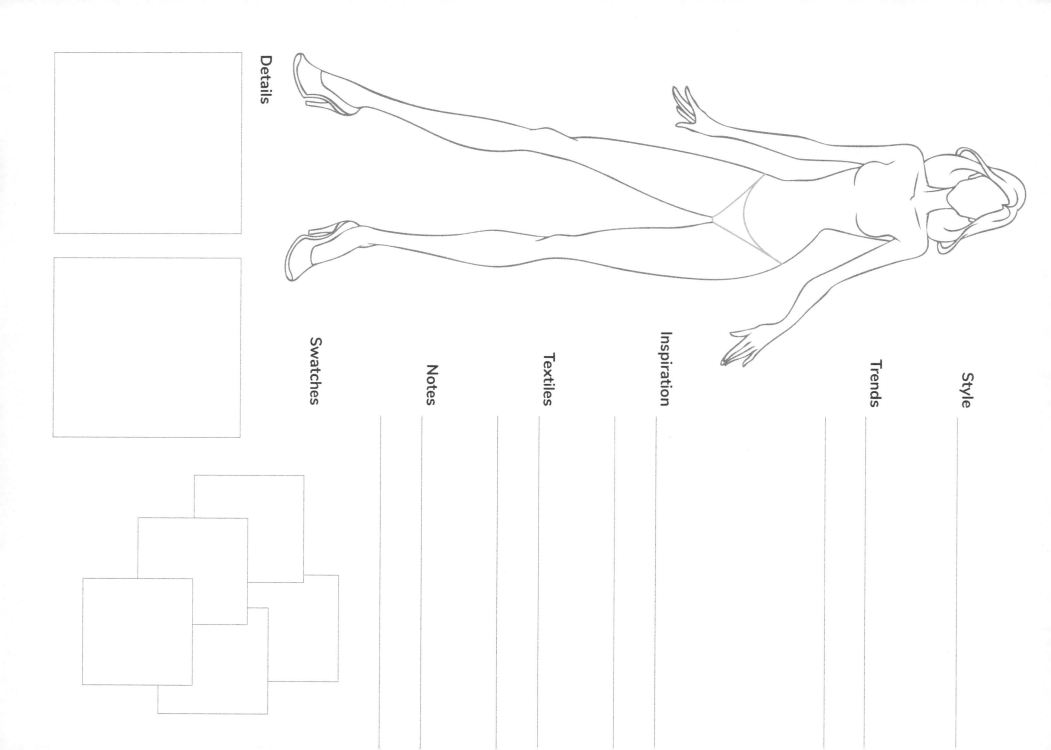

Details

Swatches

Notes

Textiles

Inspiration

Trends

Style

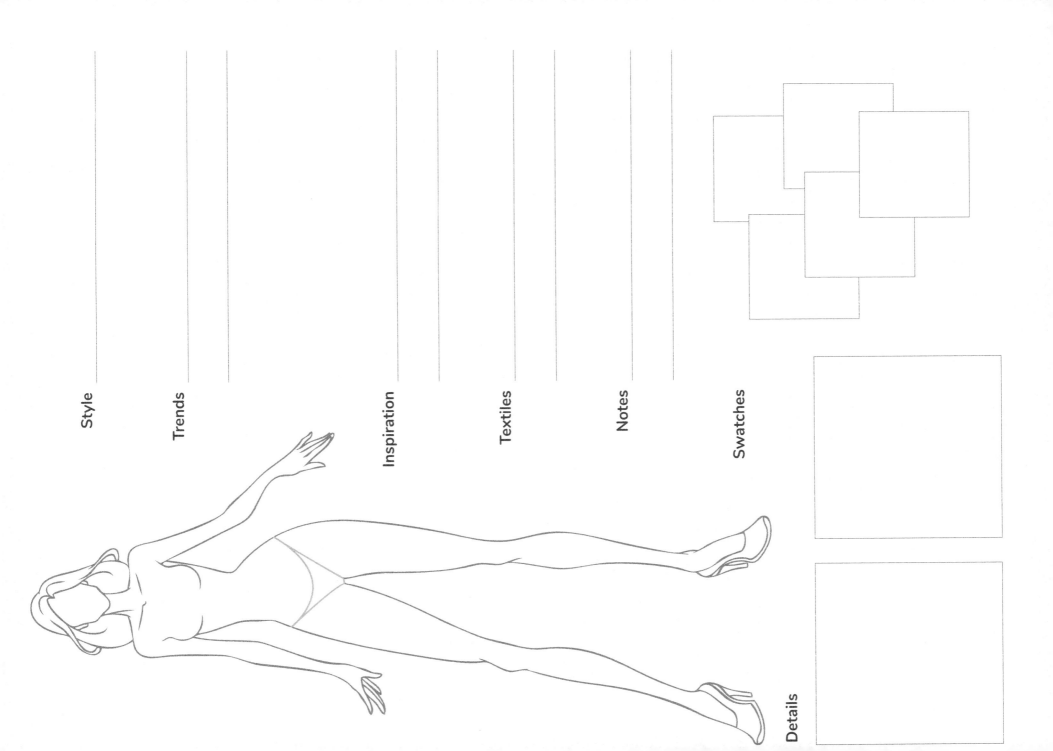

Style

Trends

Inspiration

Textiles

Notes

Swatches

Details

Details

Style

Trends

Inspiration

Textiles

Notes

Swatches

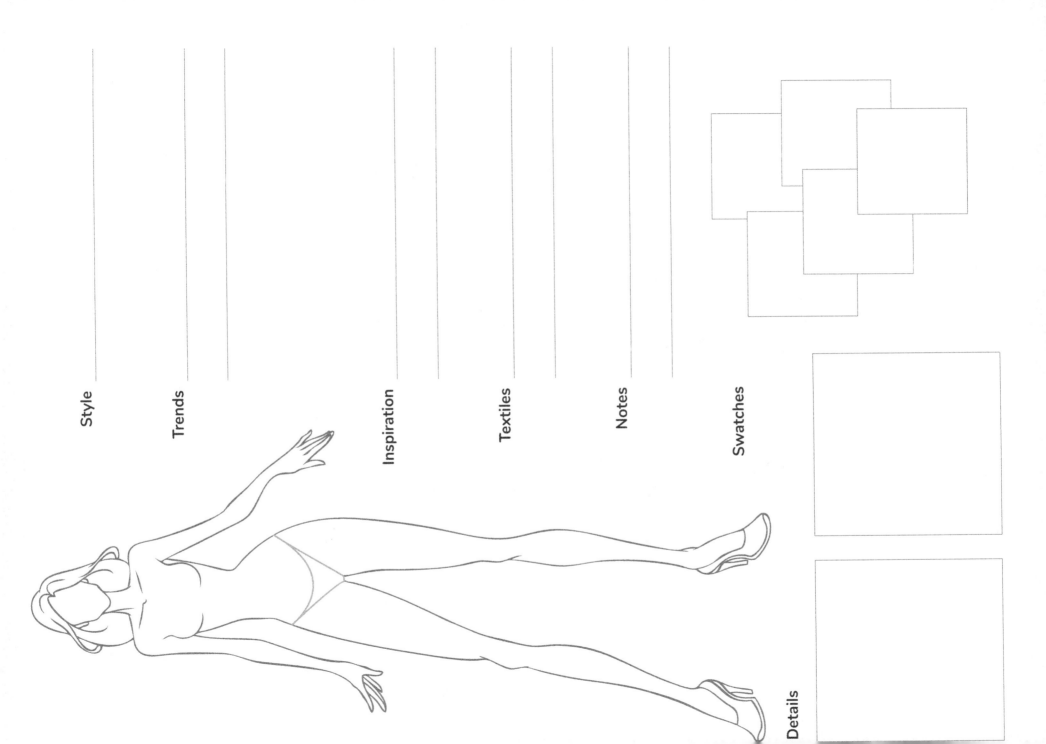

Style

Trends

Inspiration

Textiles

Notes

Swatches

Details

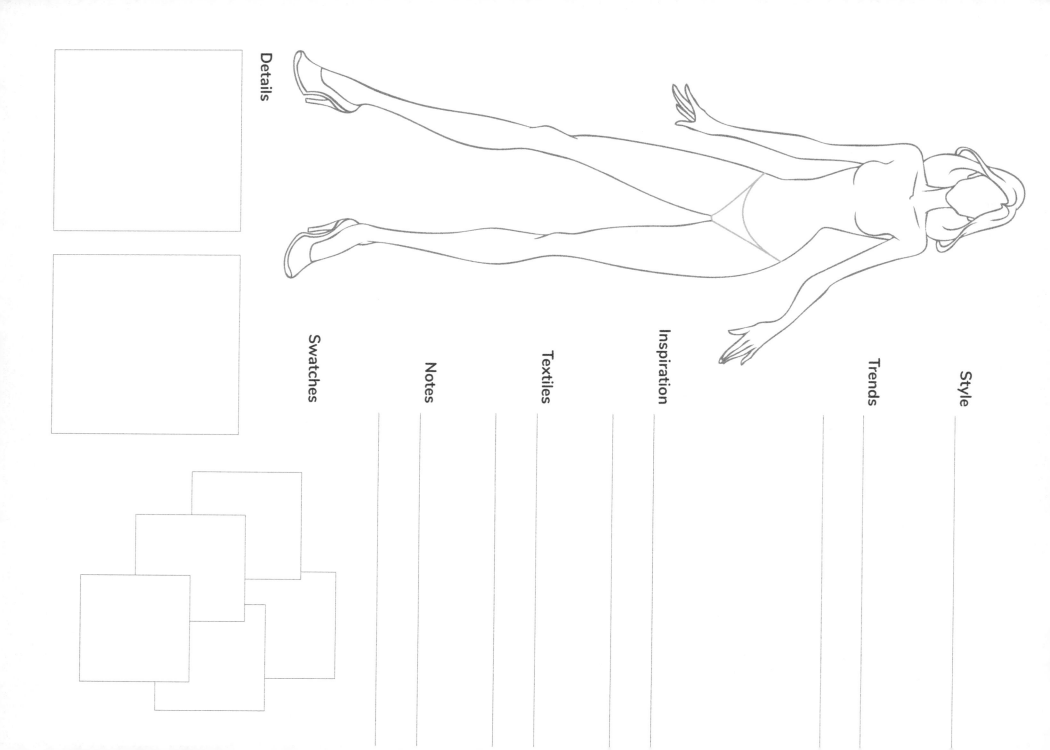

Details

Style

Swatches

Notes

Textiles

Inspiration

Trends

Style

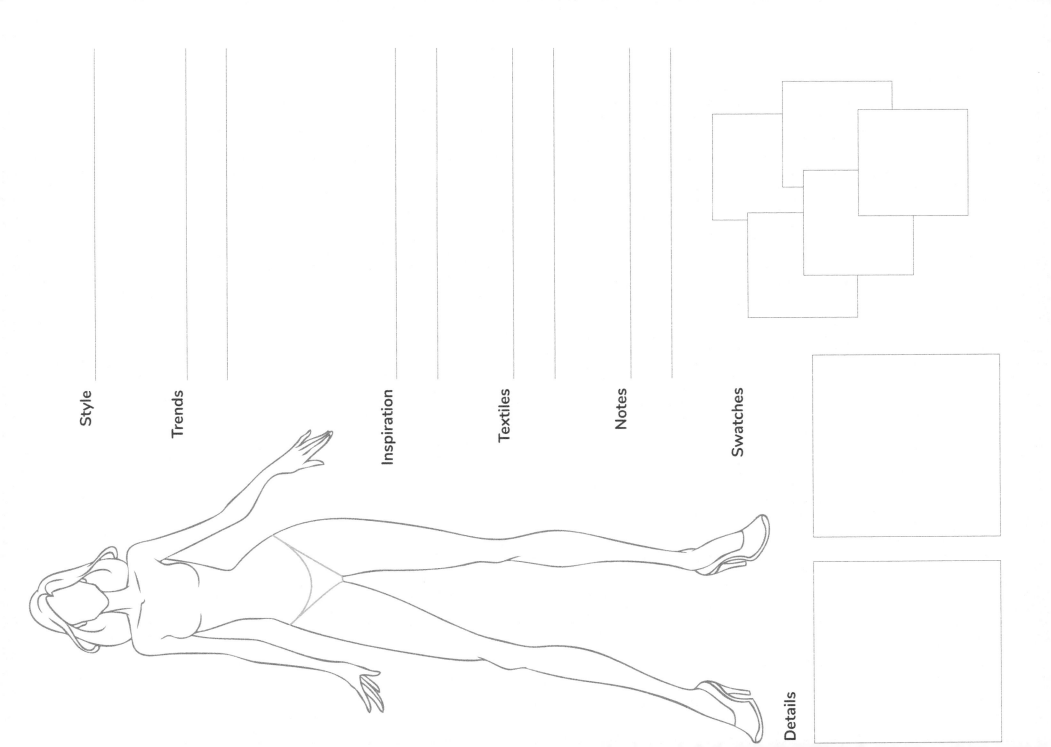

Style

Trends

Inspiration

Textiles

Notes

Swatches

Details

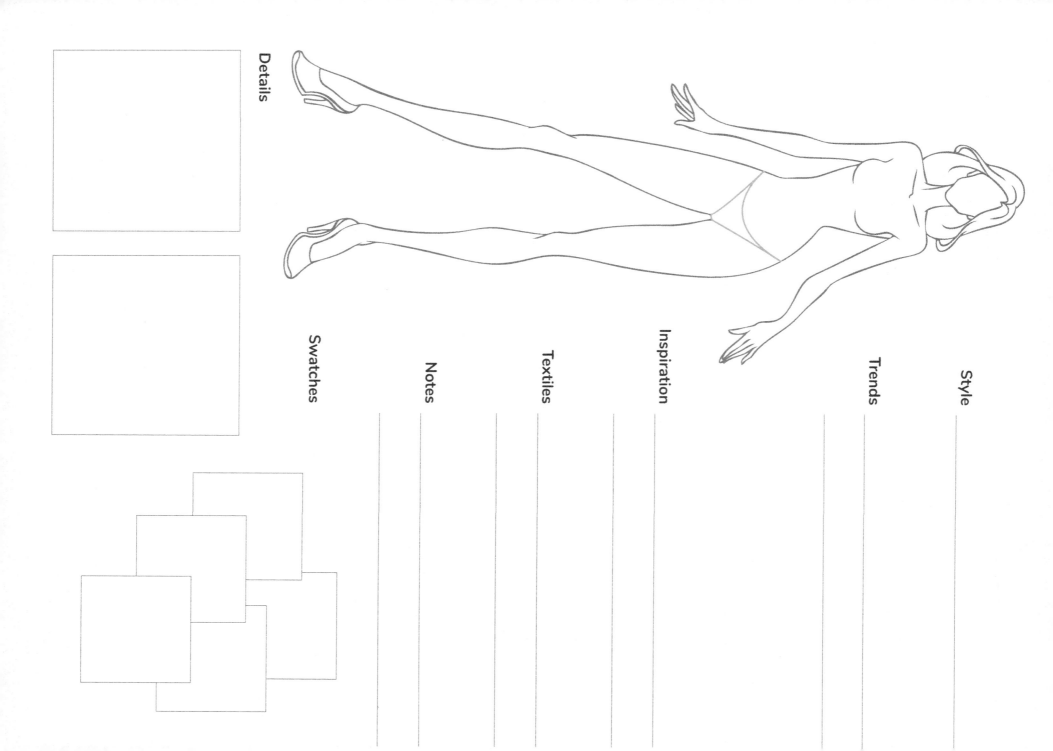

Details

Style

Swatches

Notes

Textiles

Inspiration

Trends

Style

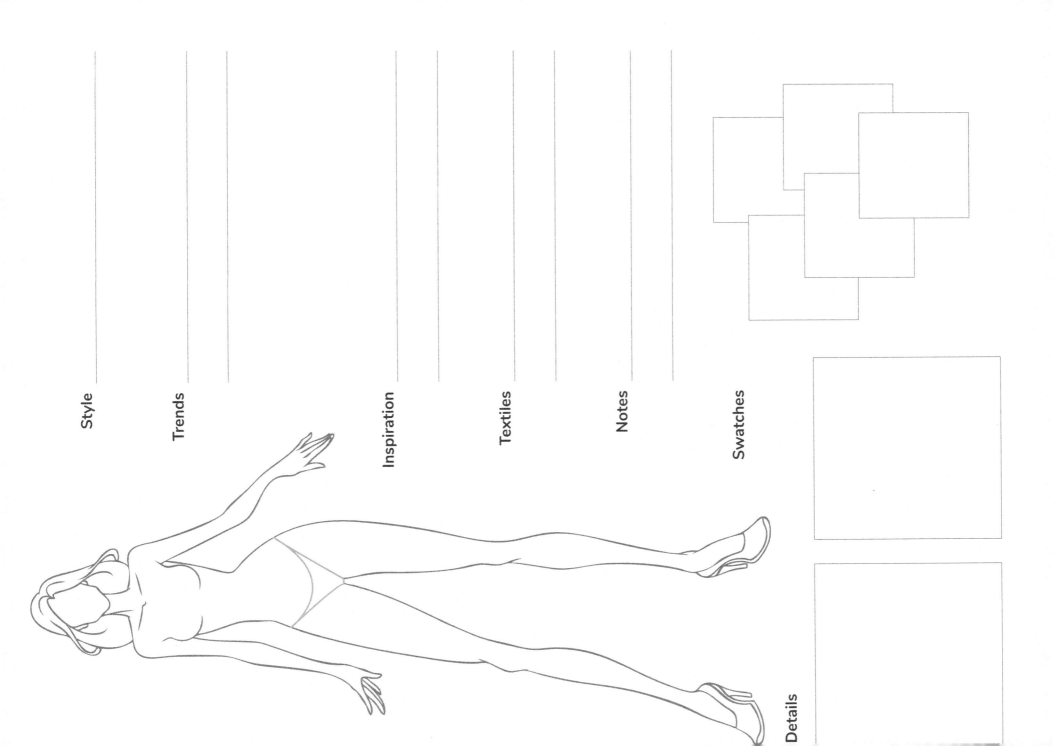

Style

Trends

Inspiration

Textiles

Notes

Swatches

Details

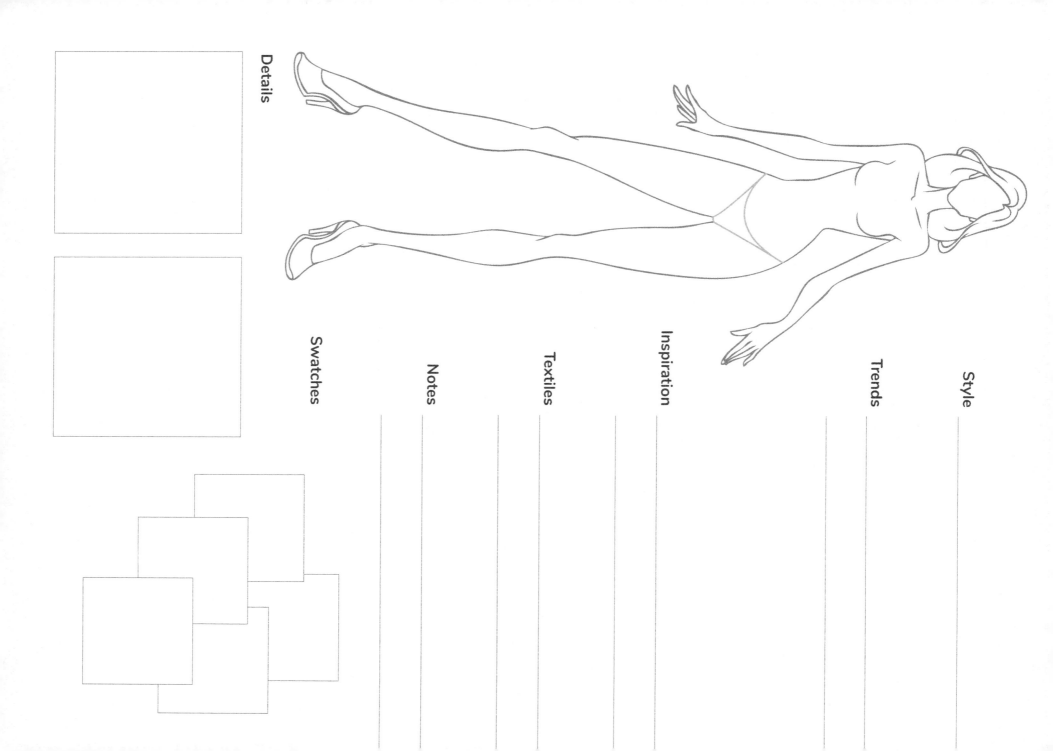

Details

Style

Trends

Inspiration

Textiles

Notes

Swatches

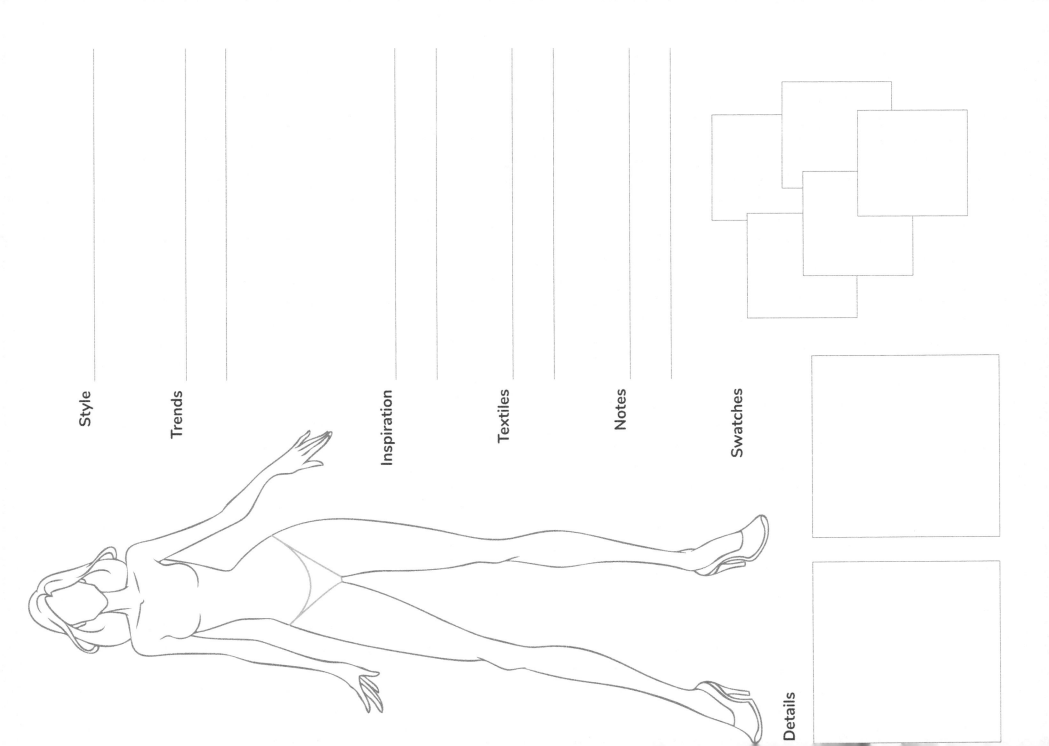

Style

Trends

Inspiration

Textiles

Notes

Swatches

Details

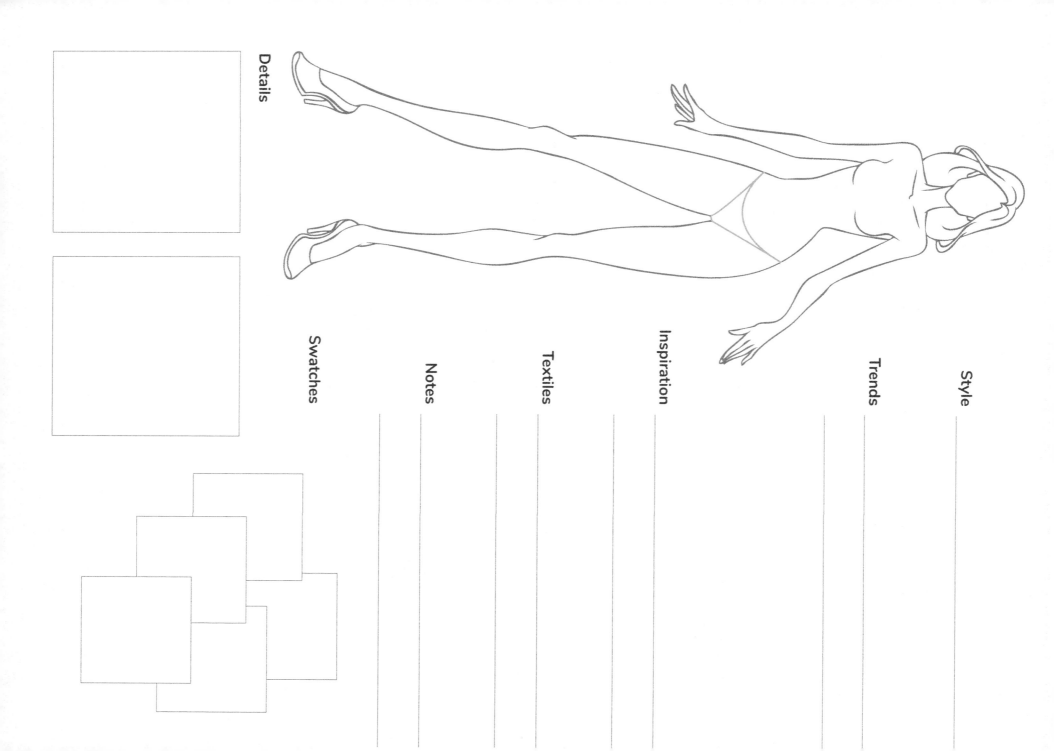

Details

Style

Swatches

Notes

Textiles

Inspiration

Trends

Style

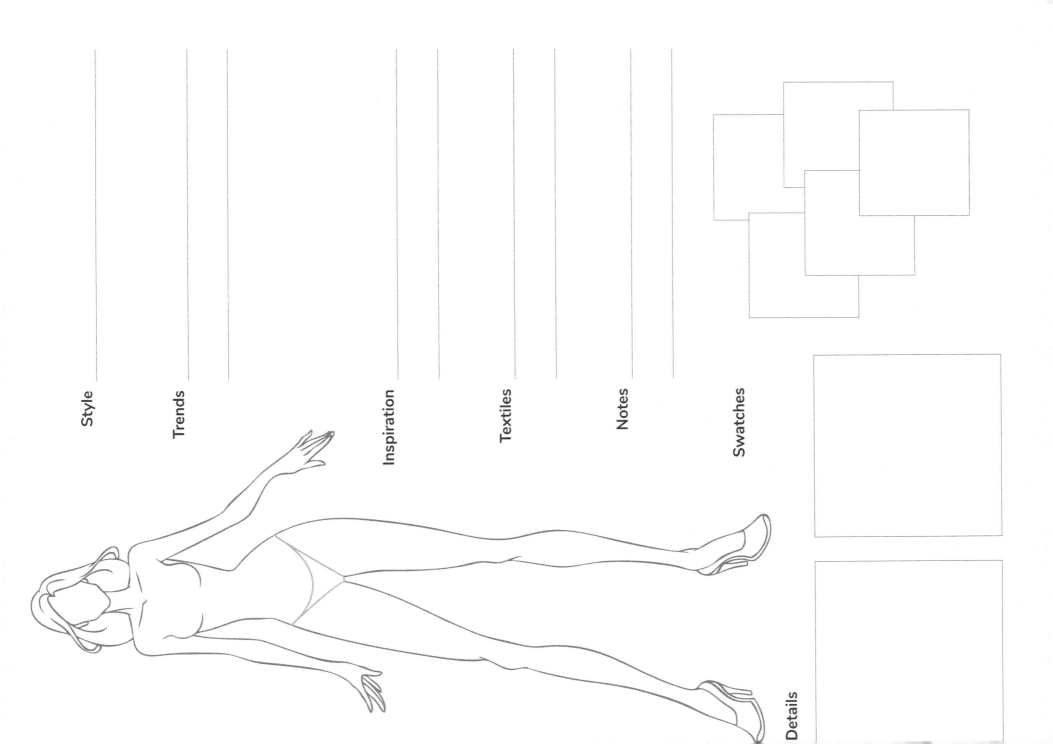

Style

Trends

Inspiration

Textiles

Notes

Swatches

Details

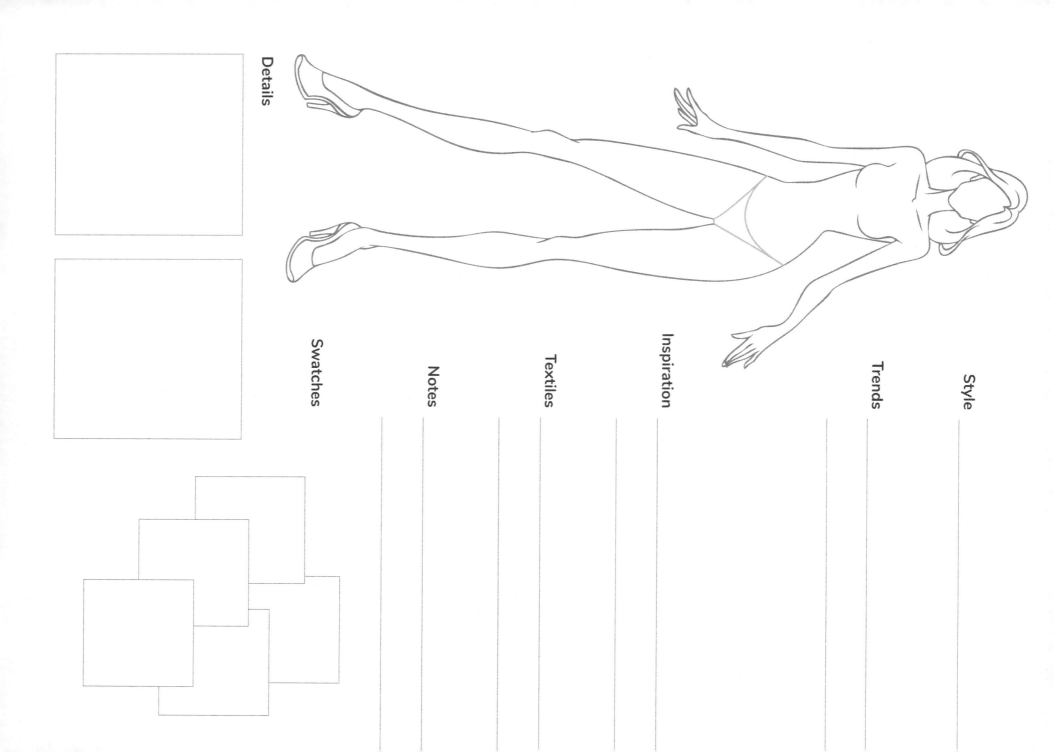

Details

Style

Trends

Inspiration

Textiles

Notes

Swatches

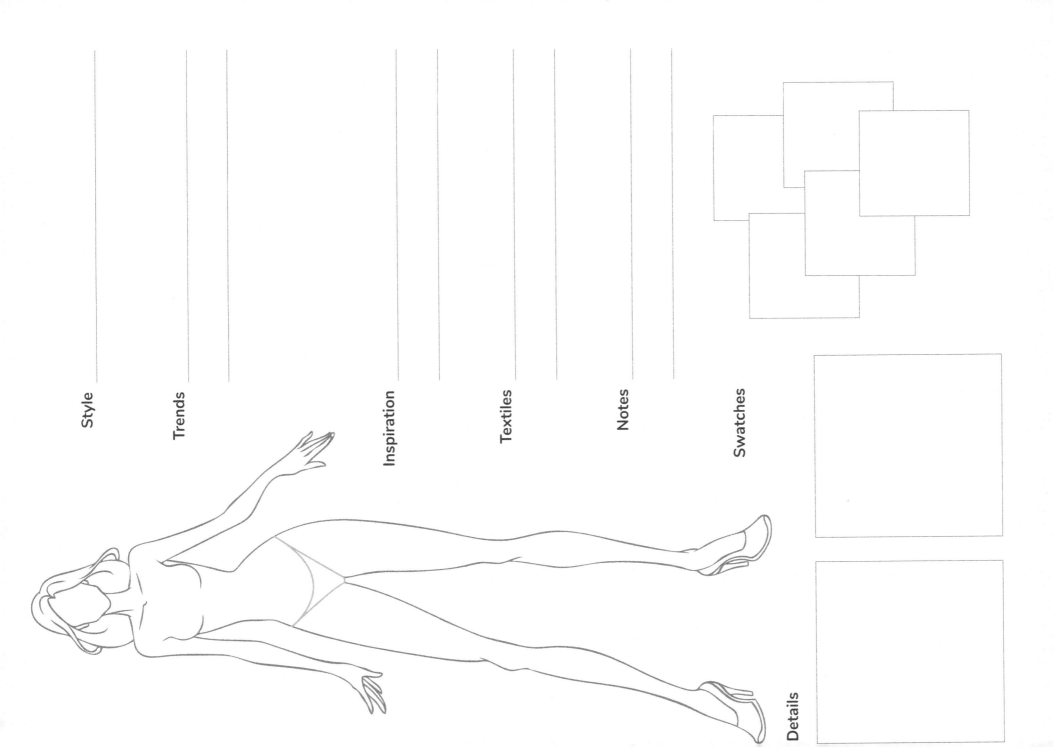

Style

Trends

Inspiration

Textiles

Notes

Swatches

Details

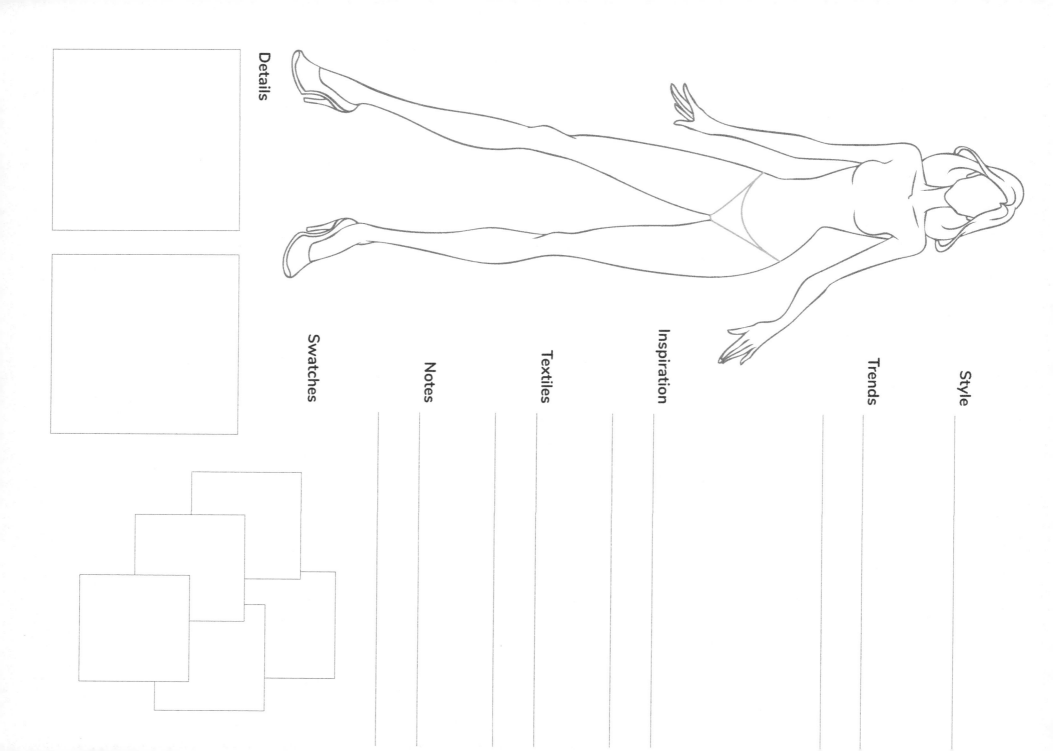

Details

Style

Trends

Inspiration

Textiles

Notes

Swatches

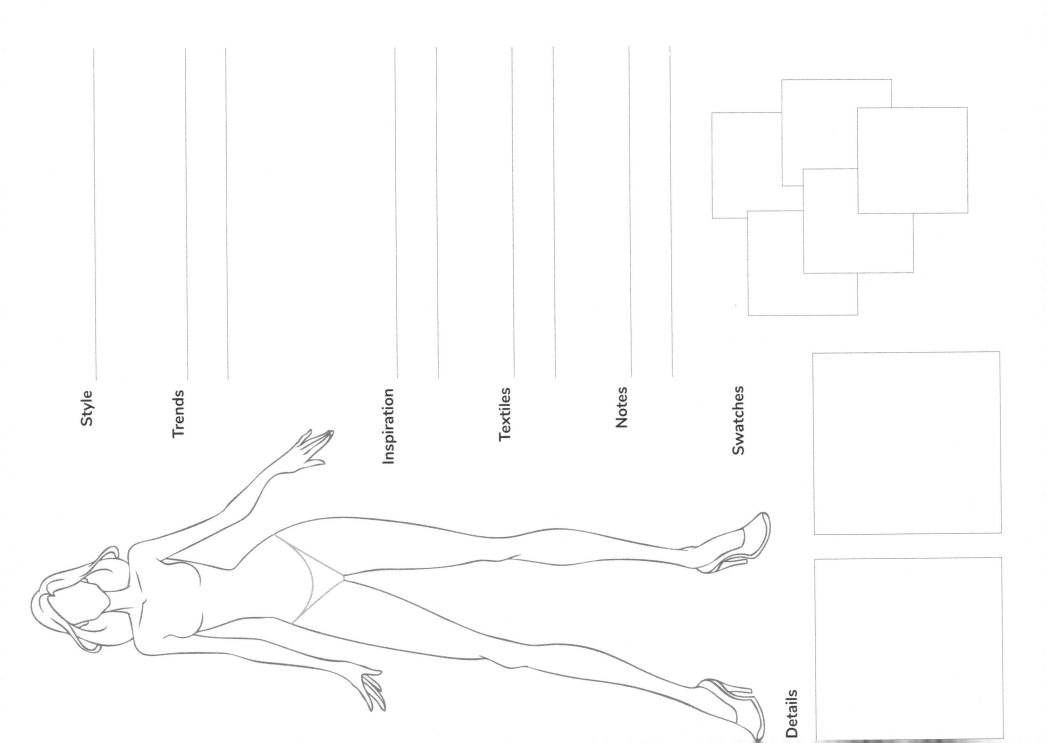

Style

Trends

Inspiration

Textiles

Notes

Swatches

Details

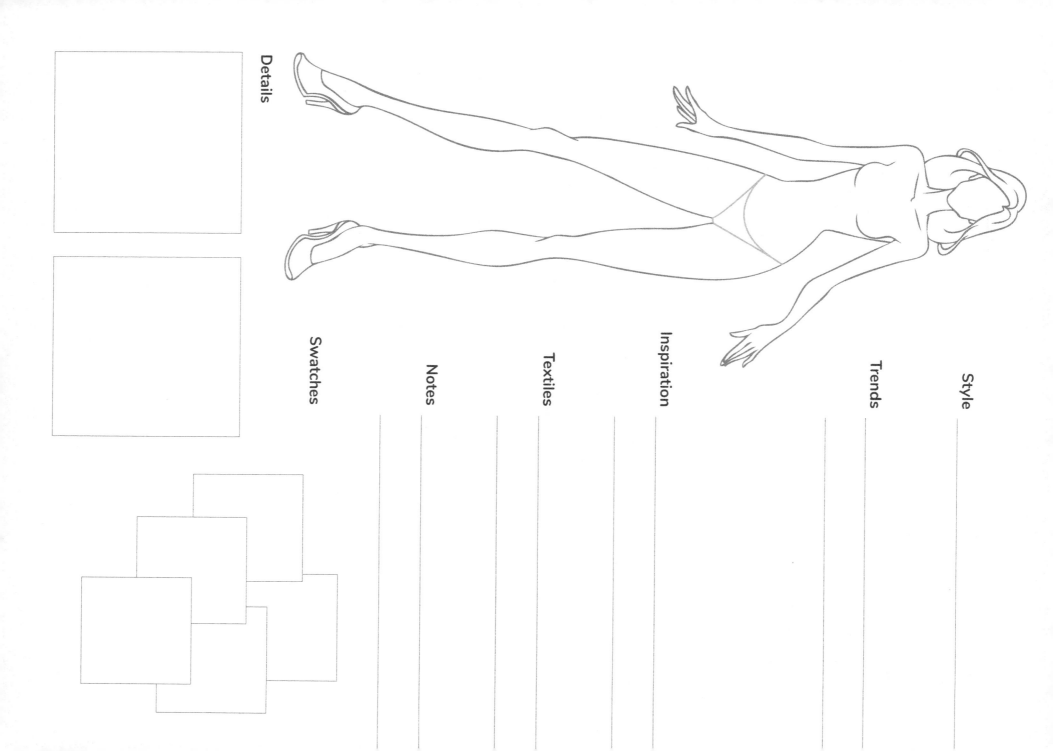

Details

Style

Trends

Inspiration

Textiles

Notes

Swatches

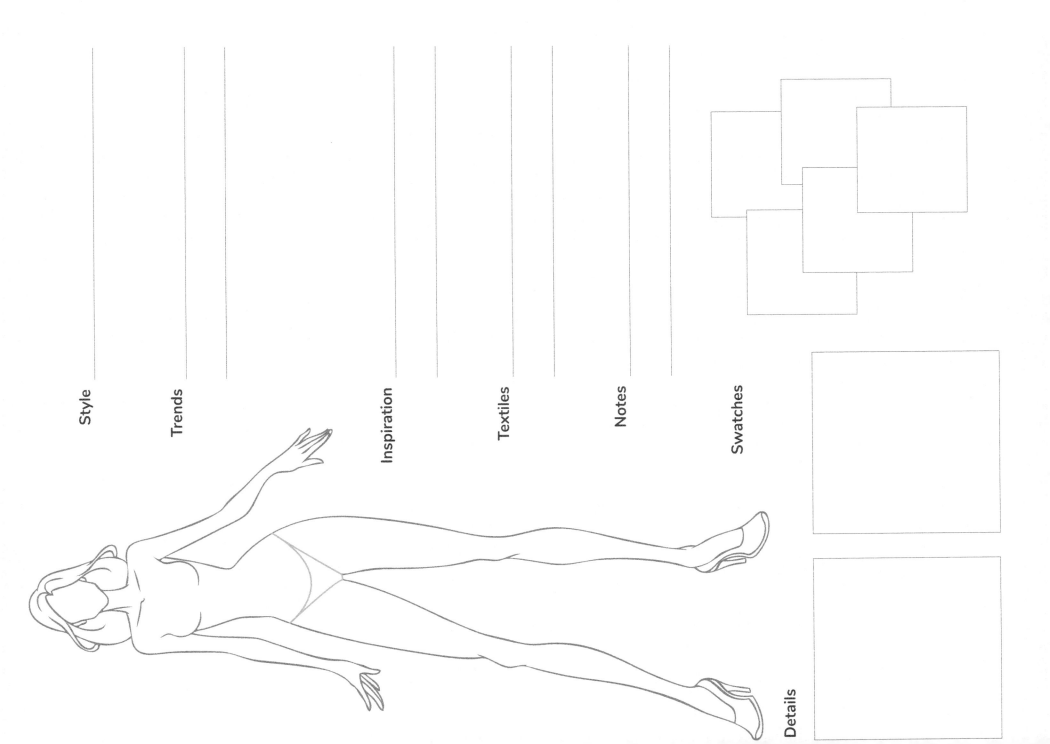

Style

Trends

Inspiration

Textiles

Notes

Swatches

Details

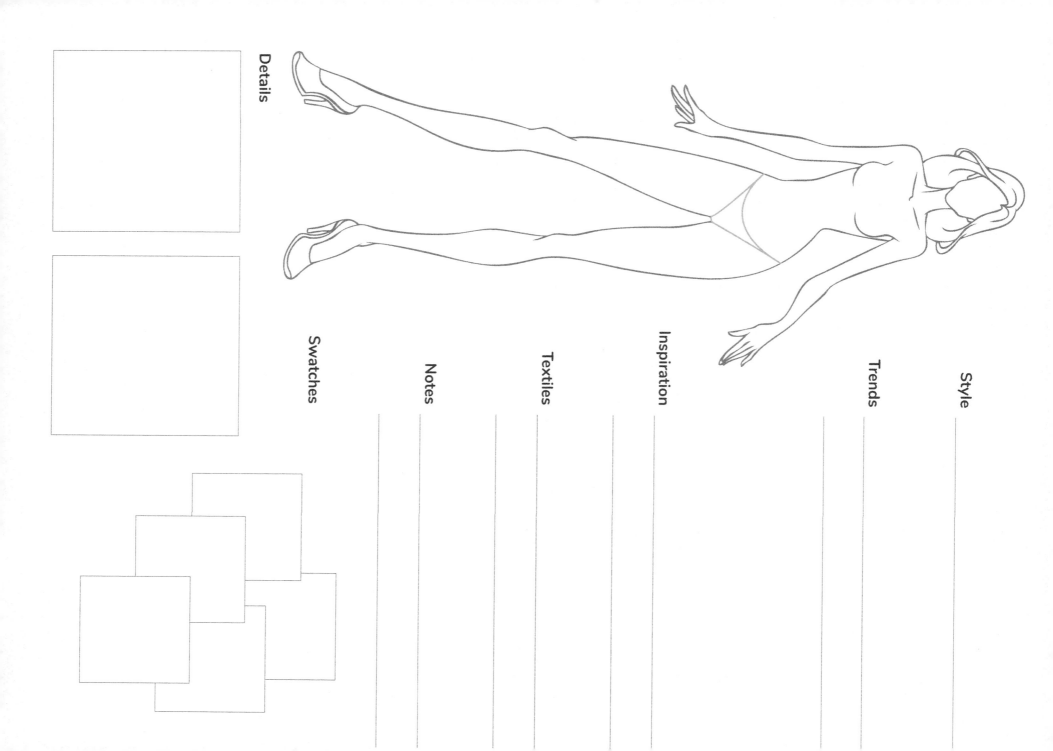

Details

Style

Trends

Inspiration

Textiles

Notes

Swatches

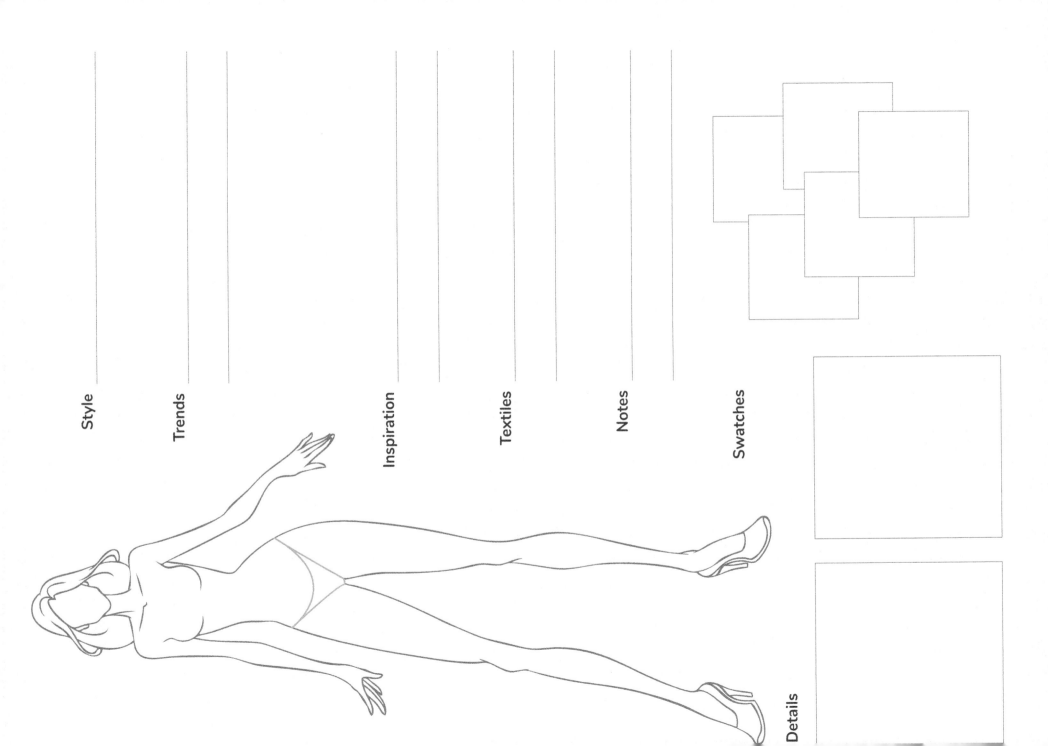

Style

Trends

Inspiration

Textiles

Notes

Swatches

Details

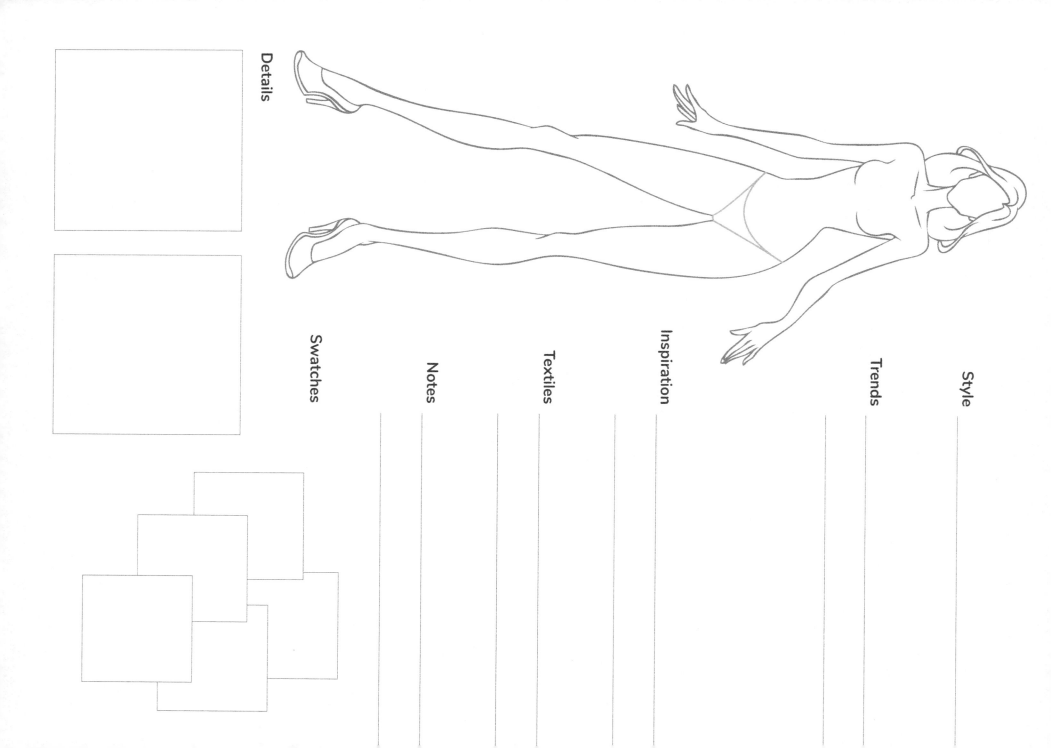

Details

Style

Trends

Inspiration

Textiles

Notes

Swatches

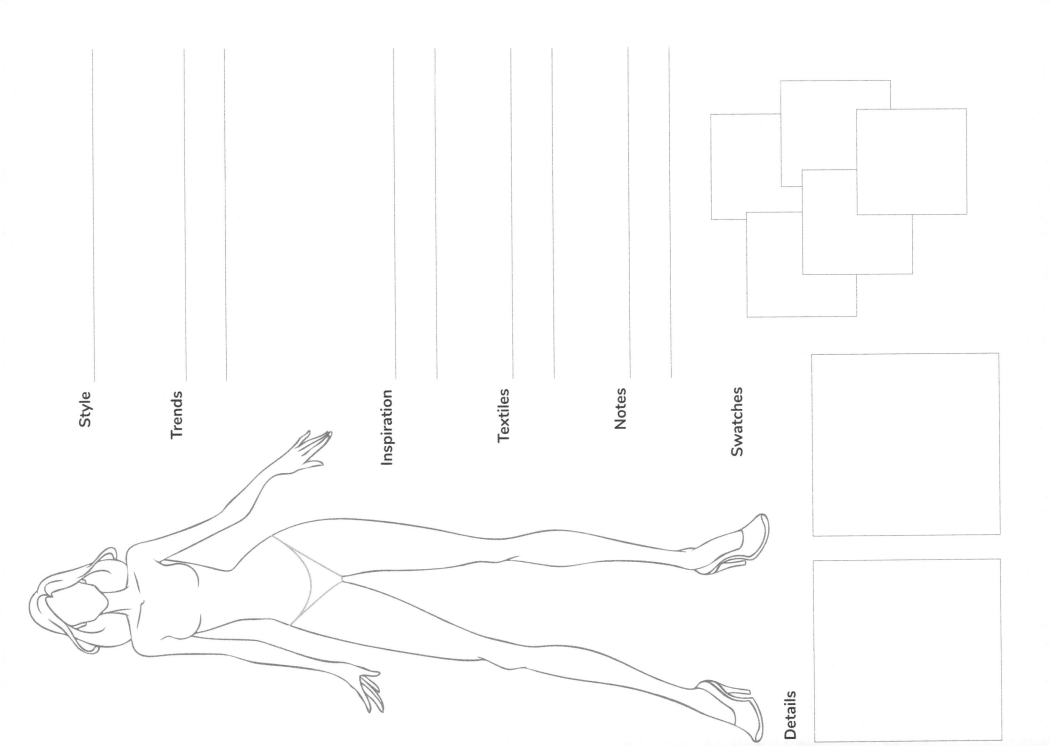

Style

Trends

Inspiration

Textiles

Notes

Swatches

Details

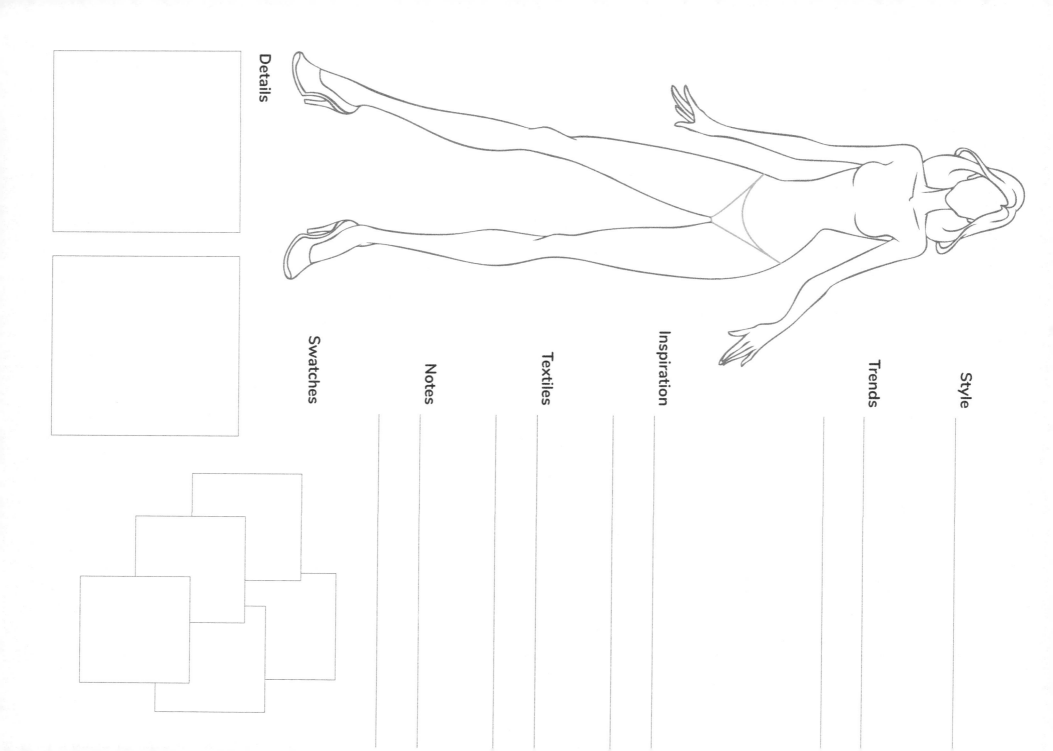

Details

Style

Trends

Inspiration

Textiles

Notes

Swatches

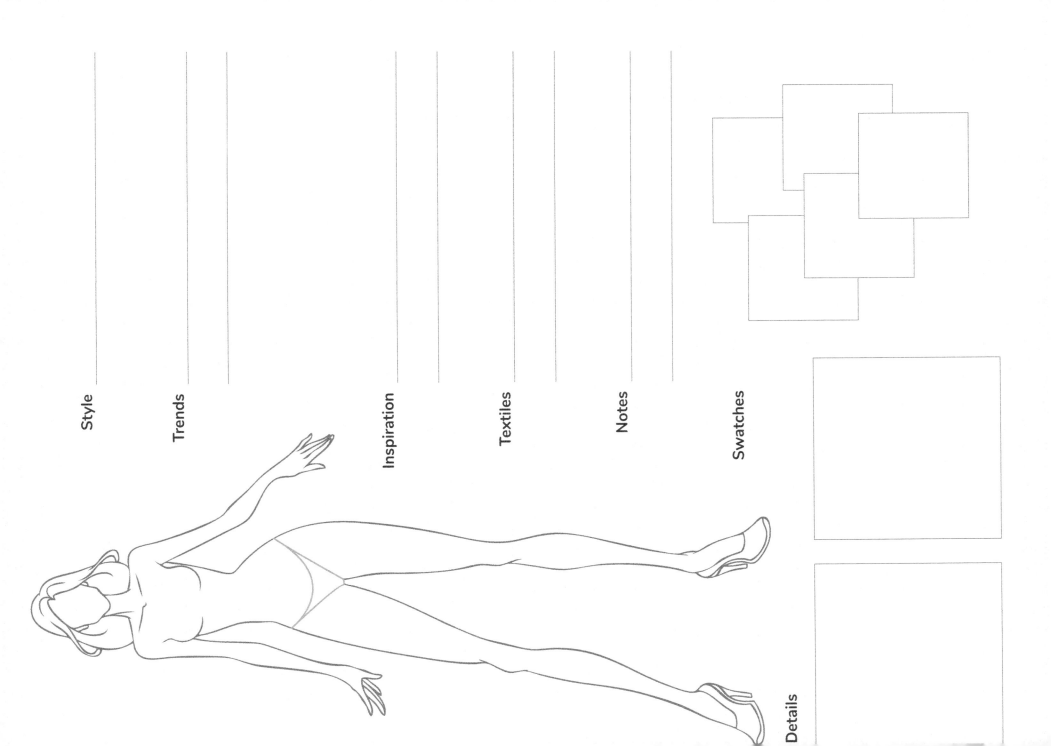

Style

Trends

Inspiration

Textiles

Notes

Swatches

Details

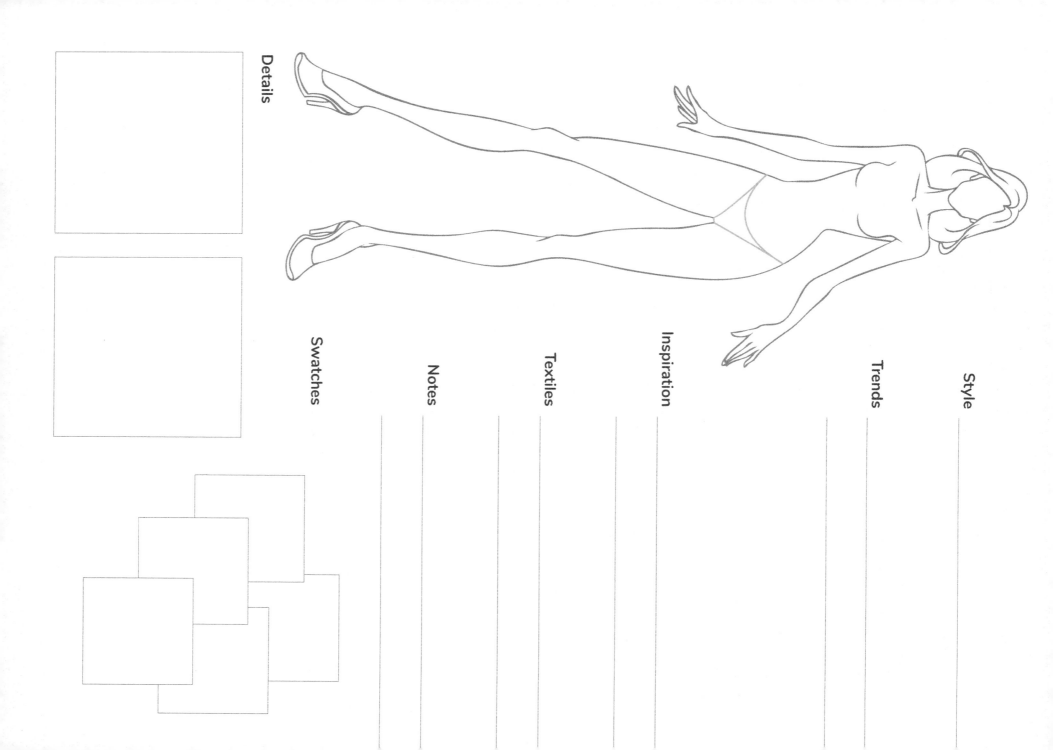

Details

Swatches

Notes

Textiles

Inspiration

Trends

Style

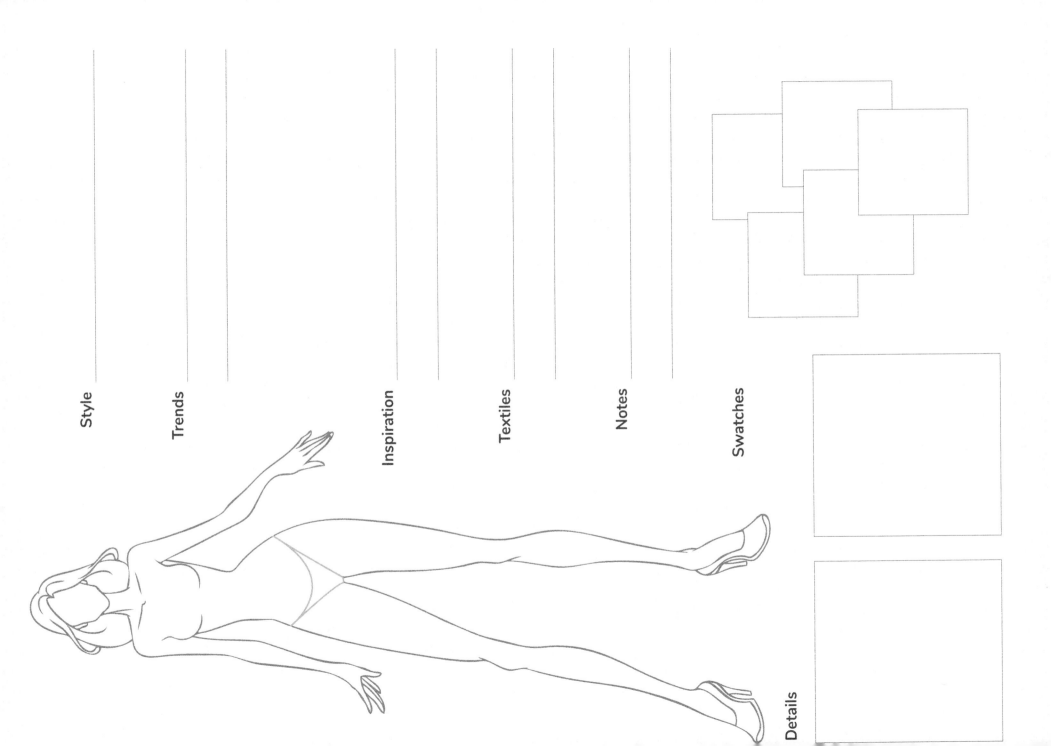

Style

Trends

Inspiration

Textiles

Notes

Swatches

Details

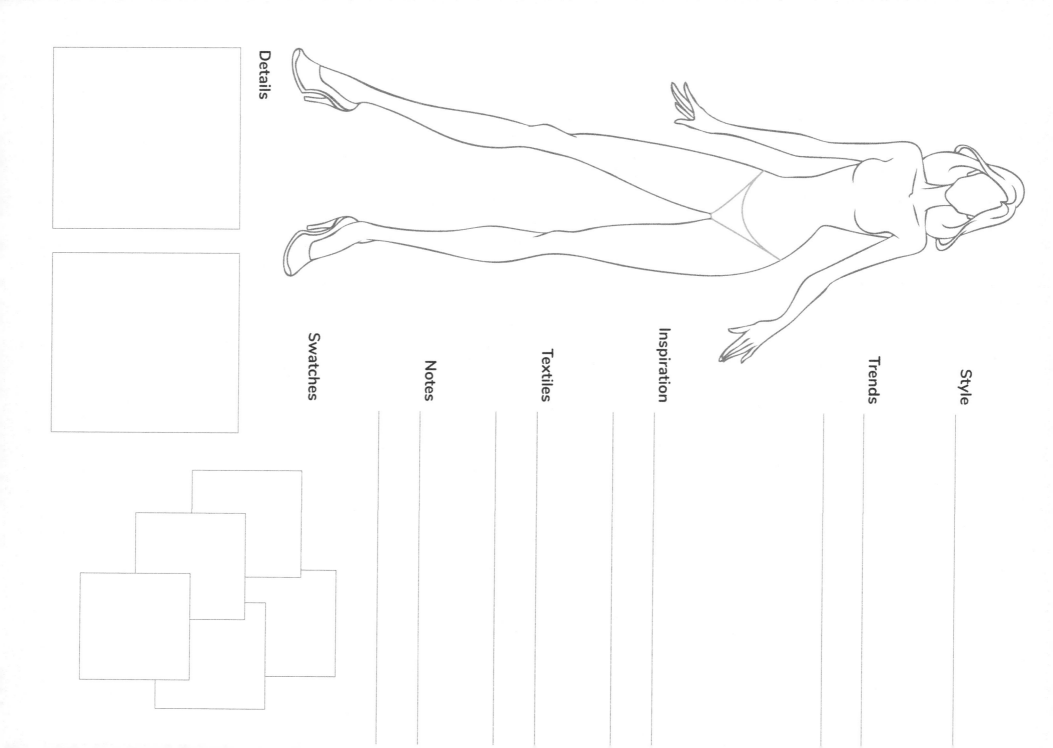

Details

Swatches

Notes

Textiles

Inspiration

Trends

Style

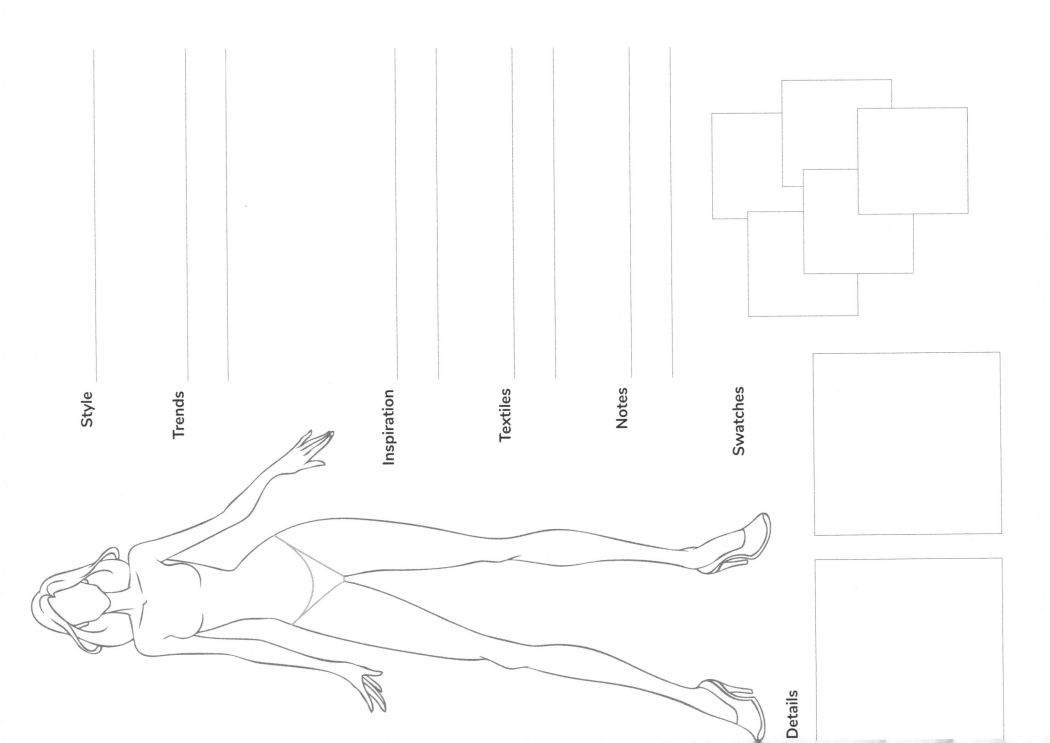

Style

Trends

Inspiration

Textiles

Notes

Swatches

Details

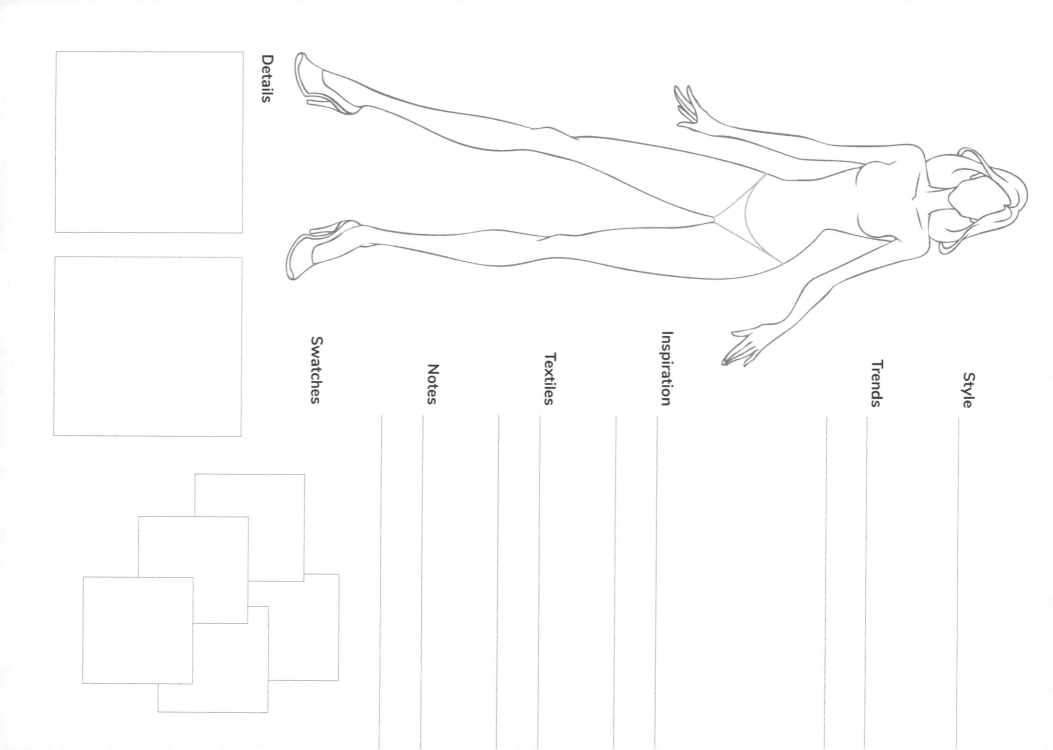

Details

Swatches

Notes

Textiles

Inspiration

Trends

Style

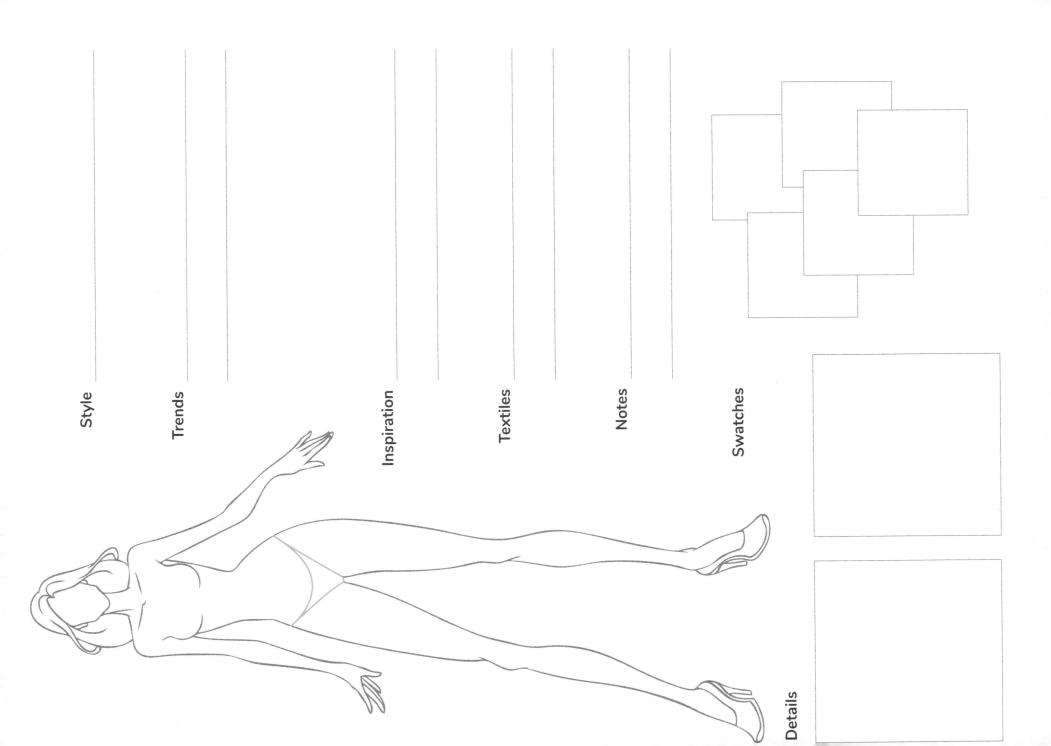

Style

Trends

Inspiration

Textiles

Notes

Swatches

Details

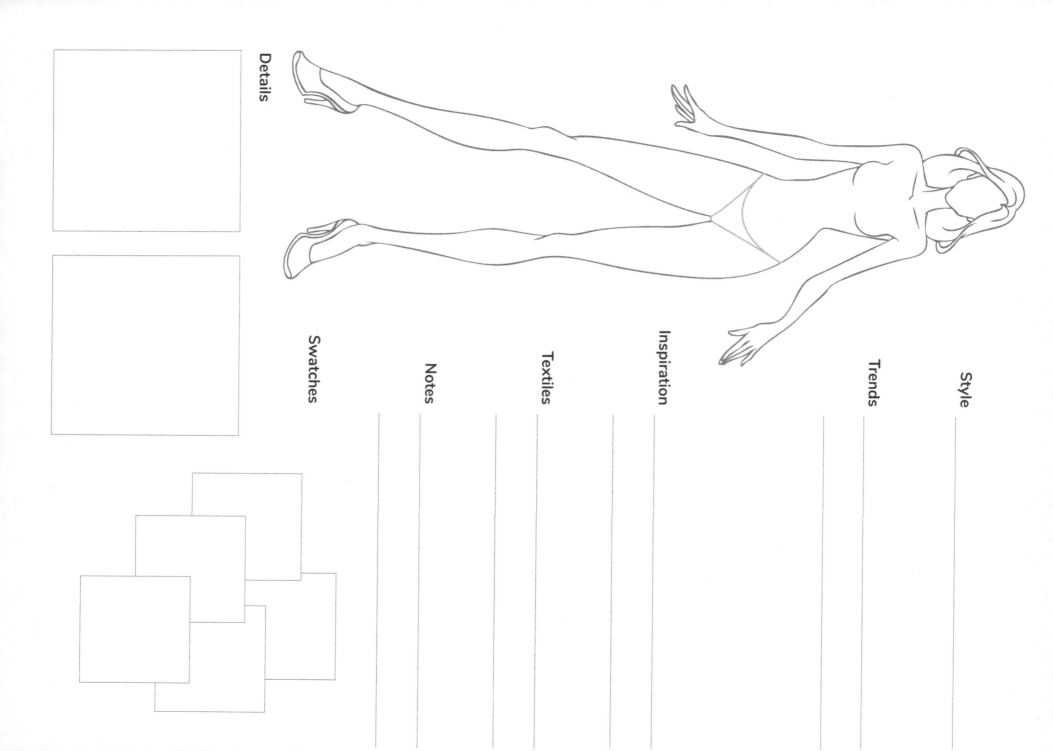

Details

Style

Swatches

Notes

Textiles

Inspiration

Trends

Style

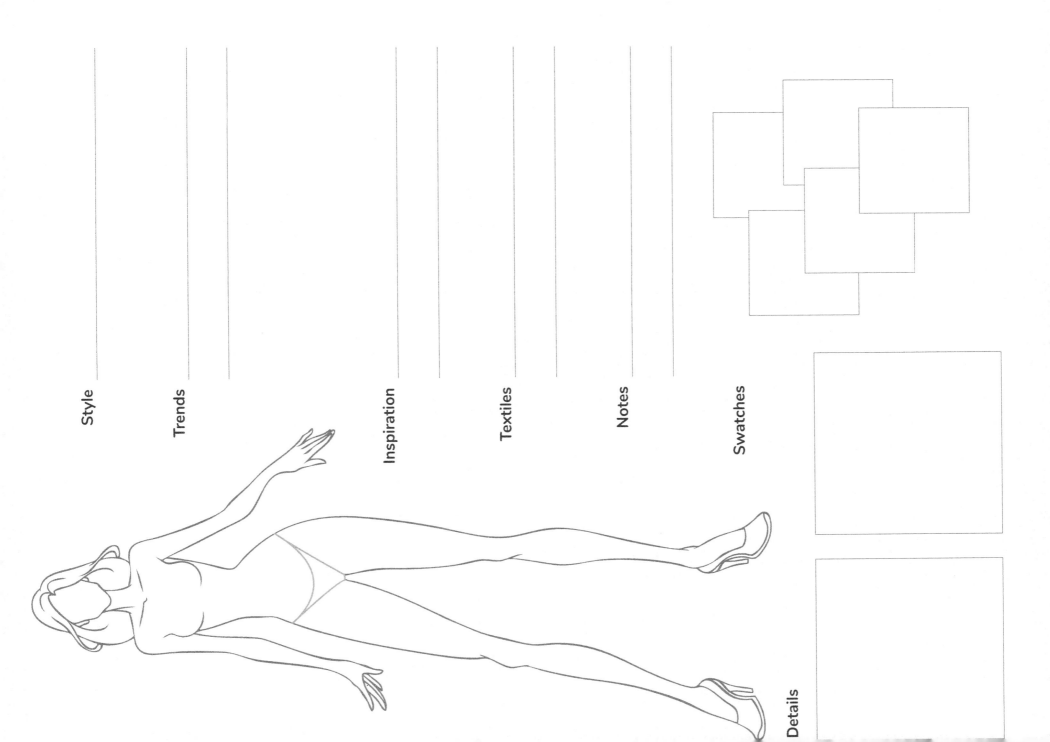

Style

Trends

Inspiration

Textiles

Notes

Swatches

Details

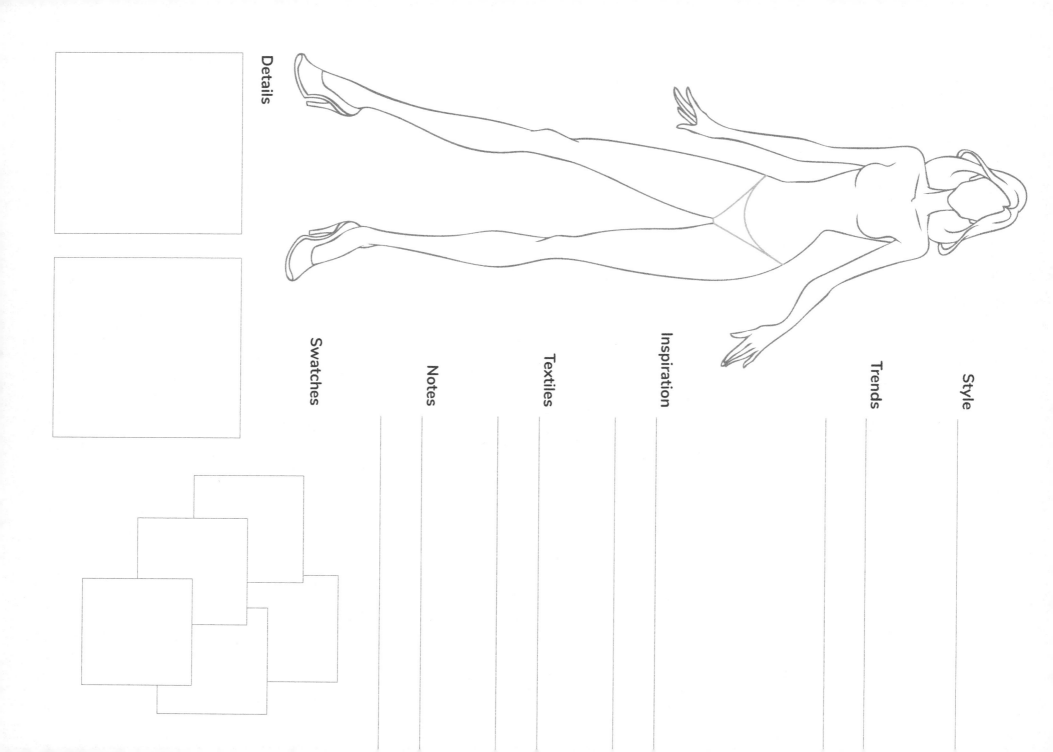

Details

Style

Trends

Inspiration

Textiles

Notes

Swatches

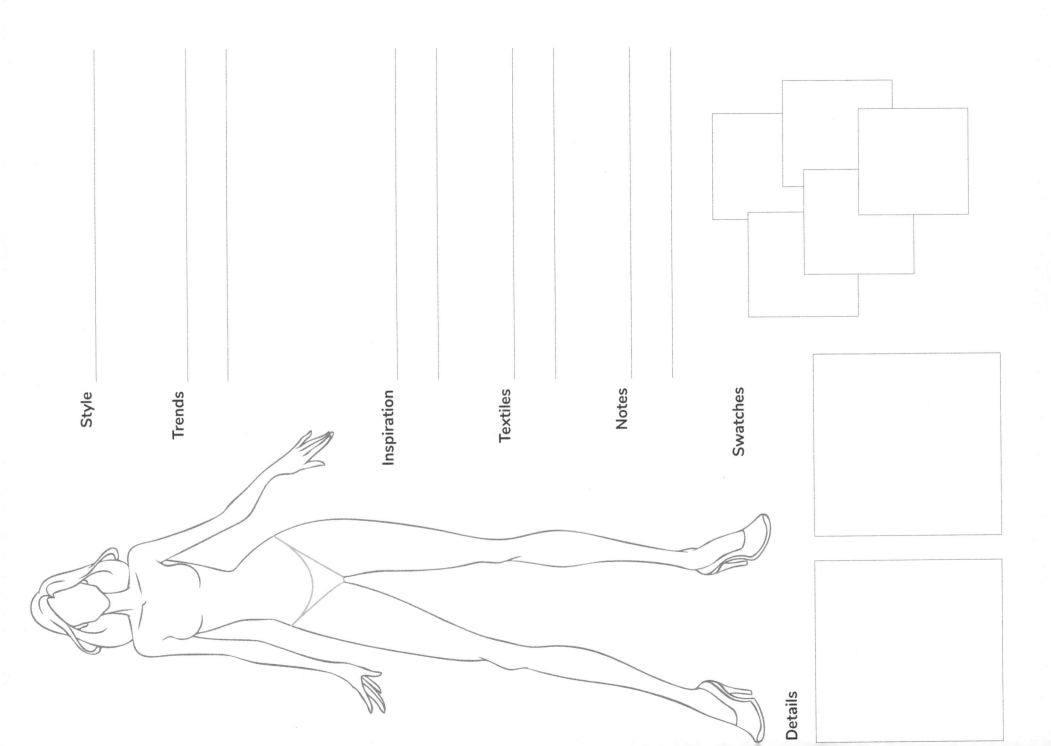

Style

Trends

Inspiration

Textiles

Notes

Swatches

Details

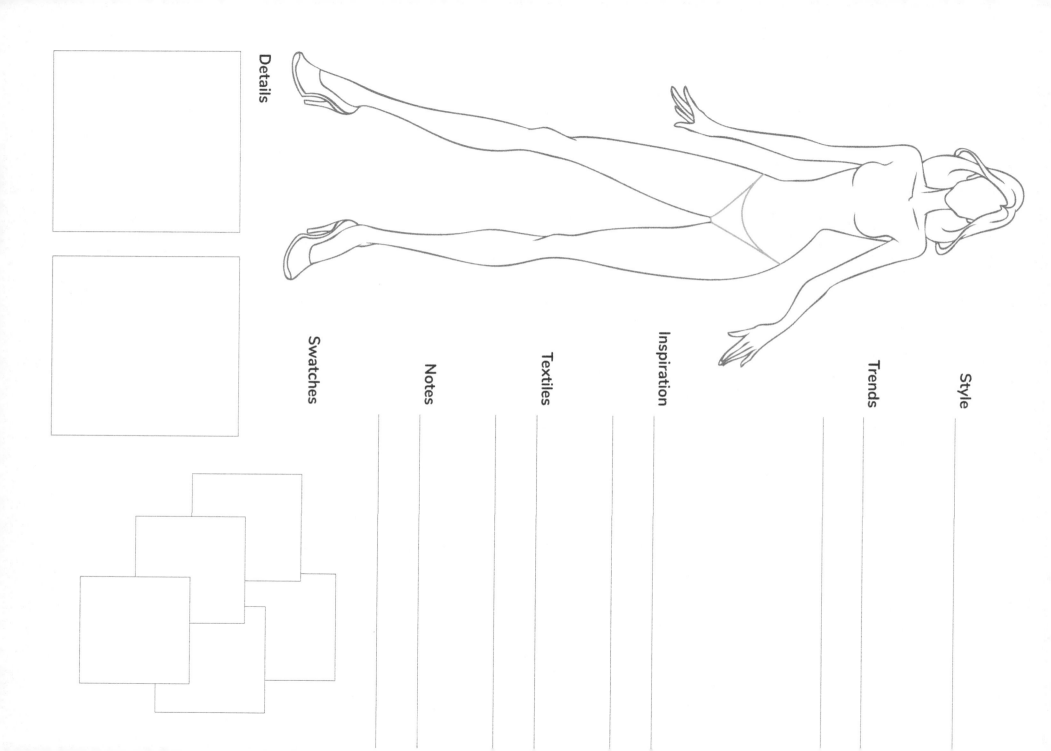

Details

Style

Trends

Inspiration

Textiles

Notes

Swatches

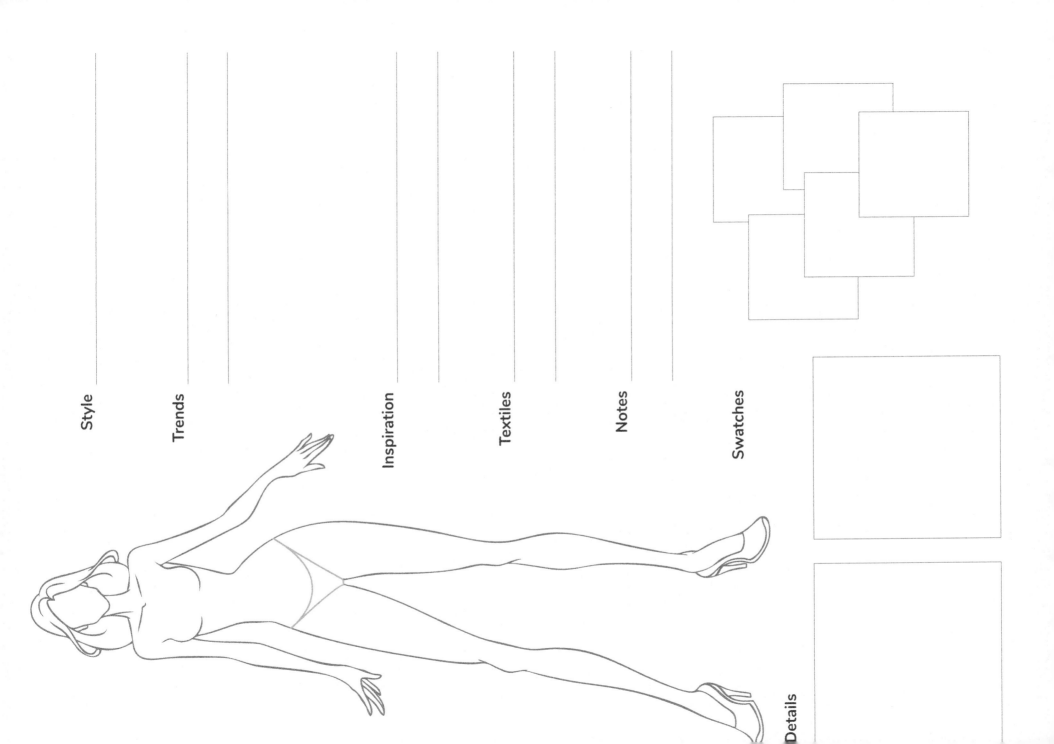

Style

Trends

Inspiration

Textiles

Notes

Swatches

Details

Details

Style

Trends

Inspiration

Textiles

Notes

Swatches

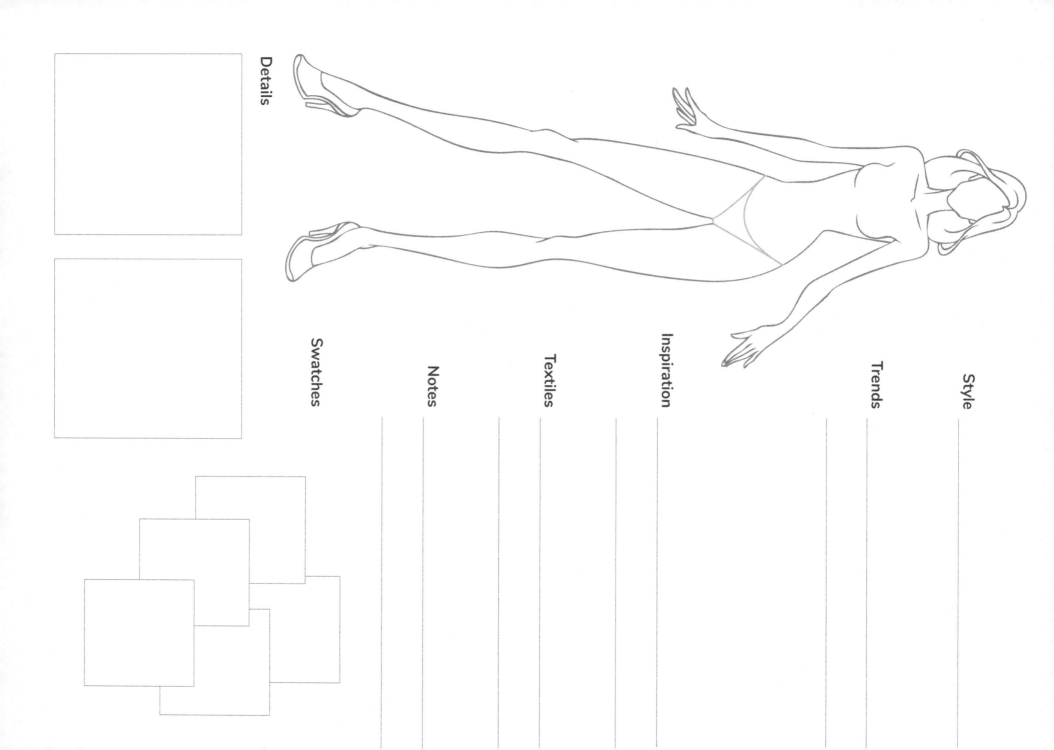

Style

Trends

Inspiration

Textiles

Notes

Swatches

Details

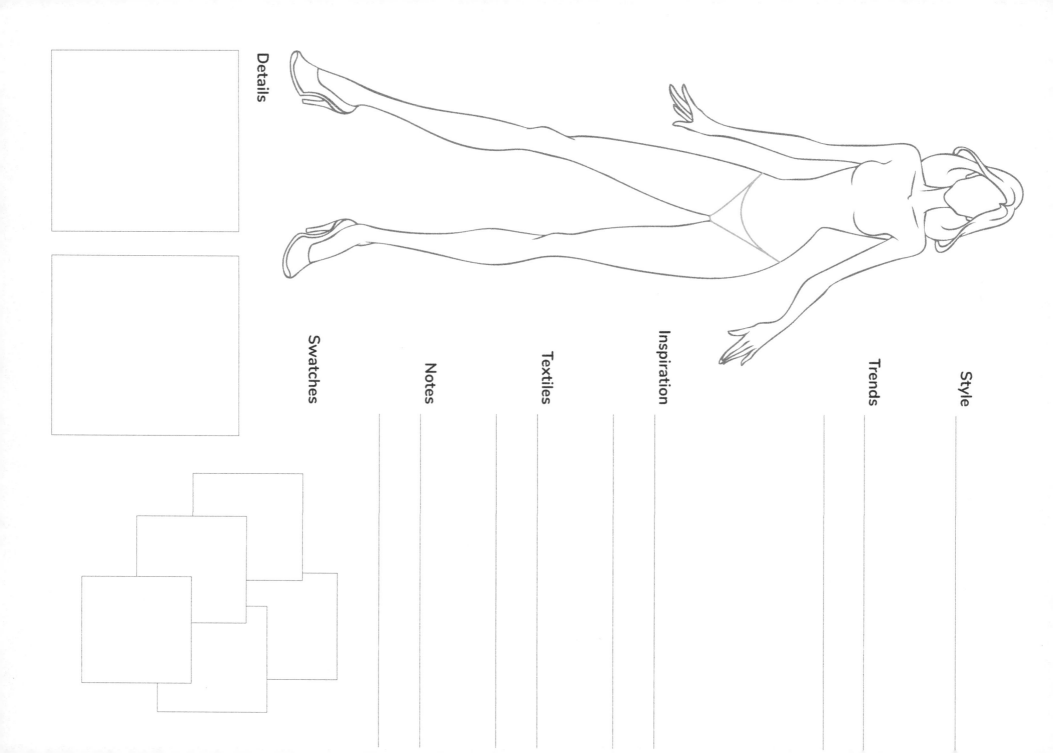

Details

Style

Swatches

Notes

Textiles

Inspiration

Trends

Style

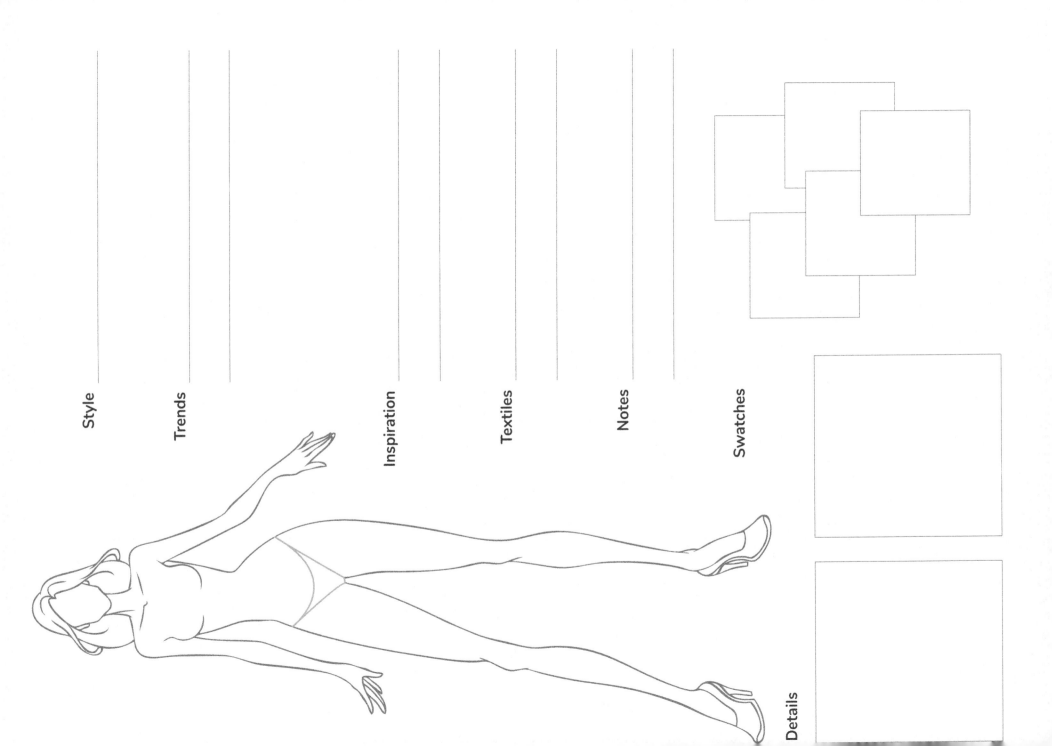

Style

Trends

Inspiration

Textiles

Notes

Swatches

Details

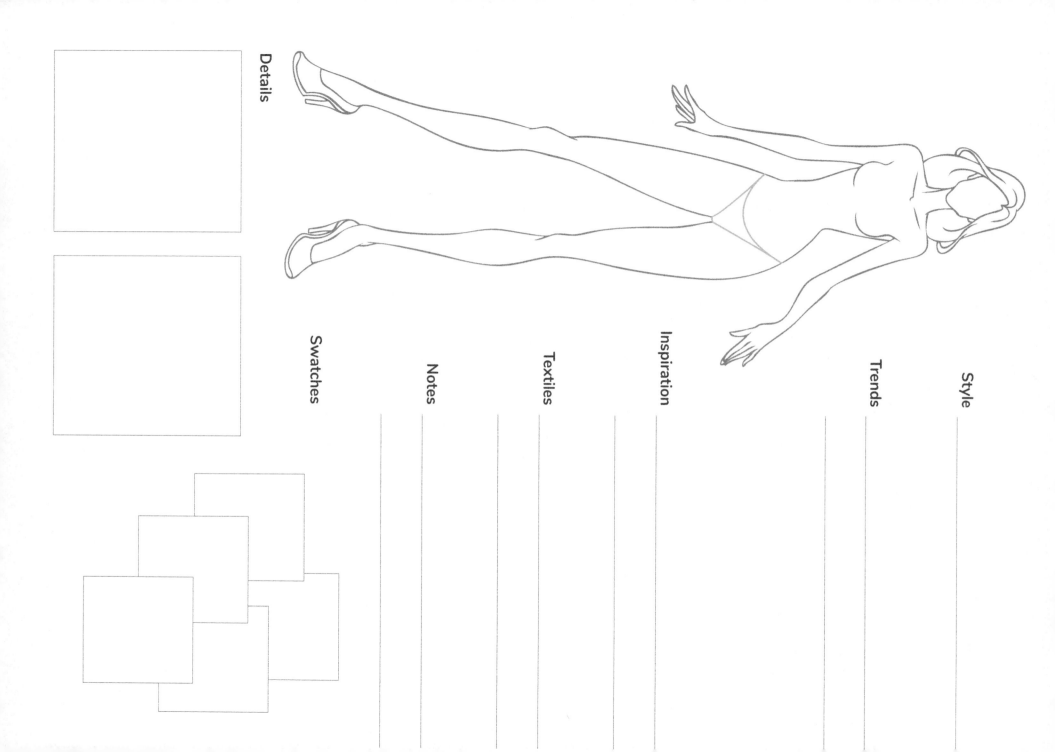

Details

Swatches

Notes

Textiles

Inspiration

Trends

Style

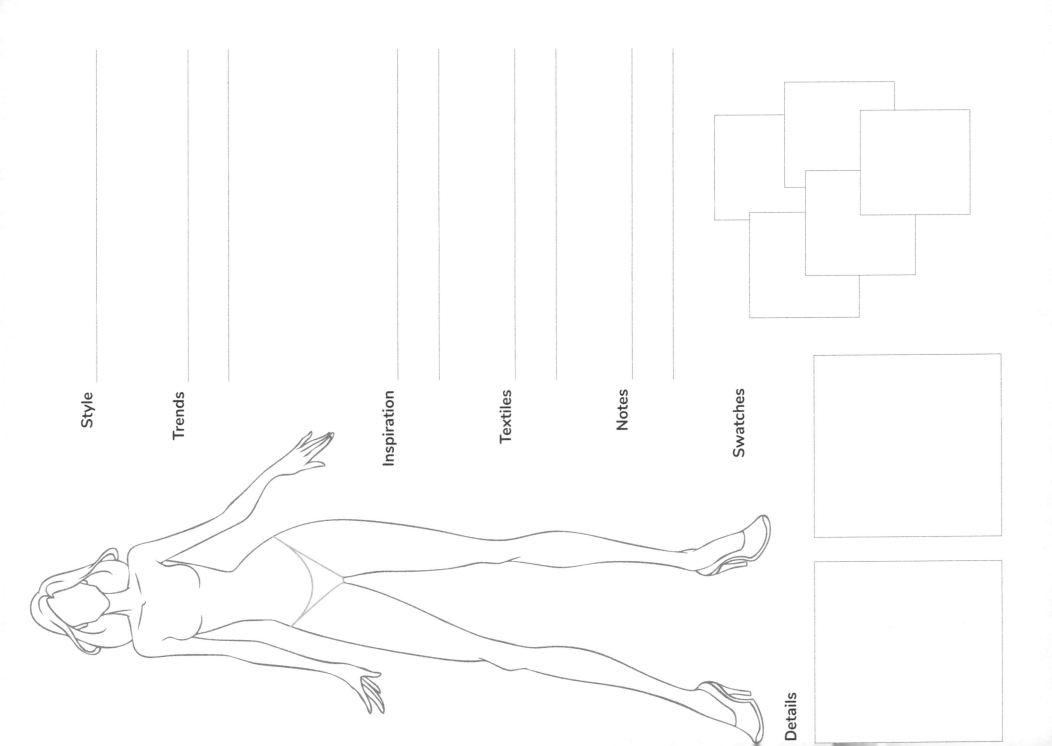

Style

Trends

Inspiration

Textiles

Notes

Swatches

Details

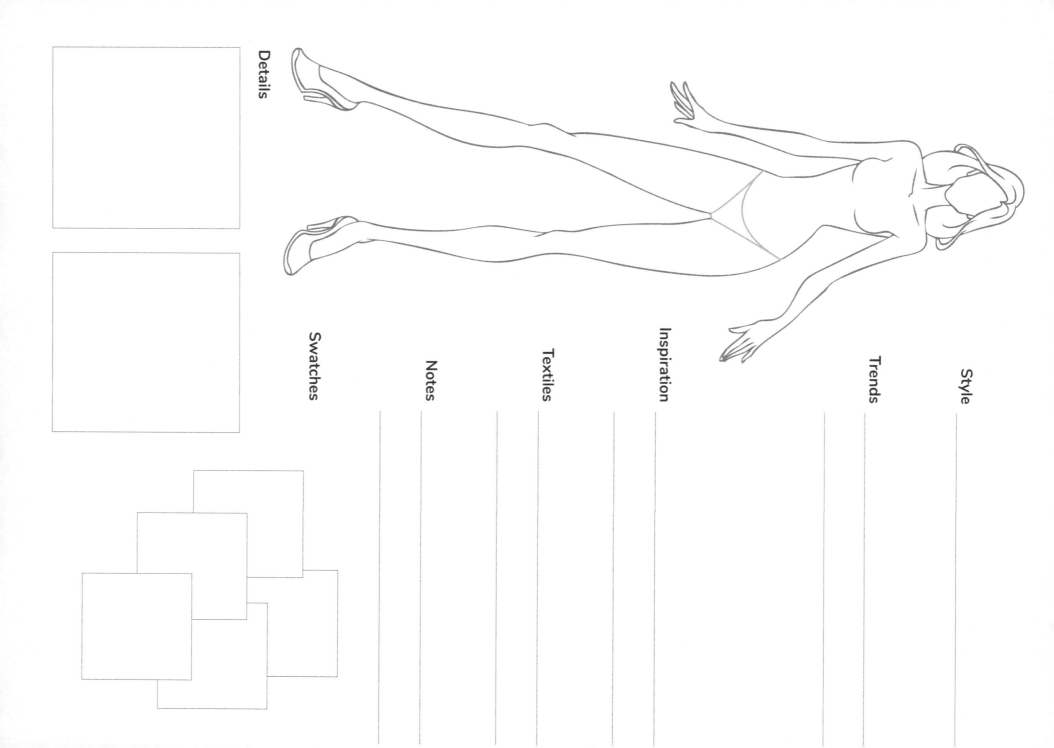

Details

Style

Trends

Inspiration

Textiles

Notes

Swatches

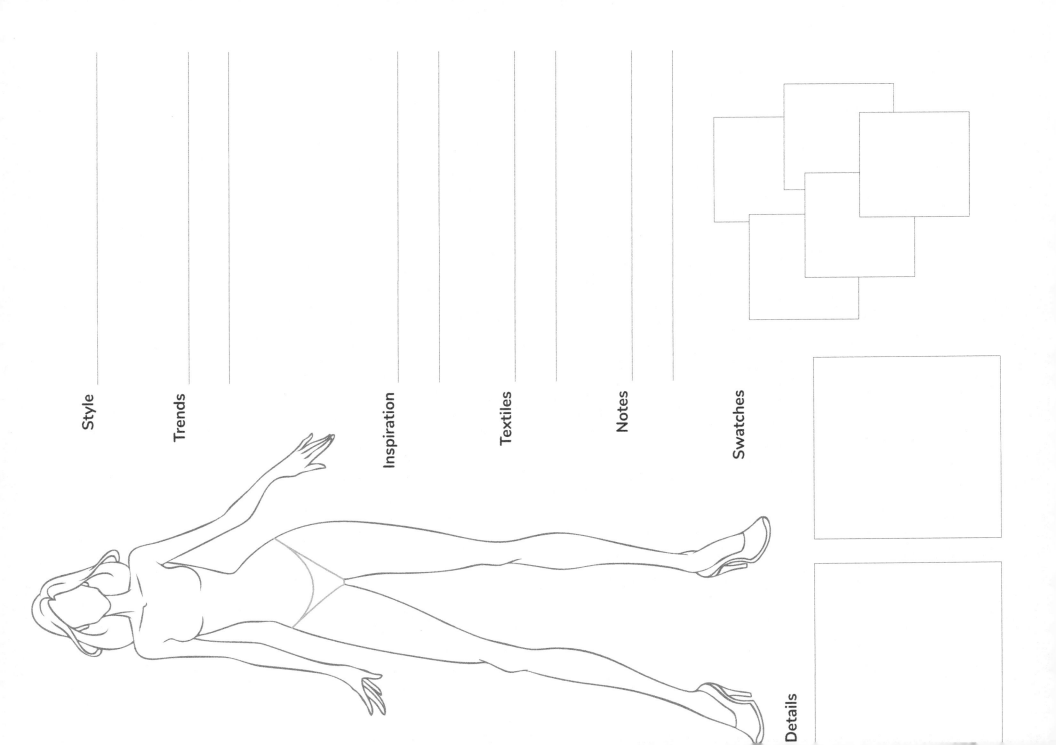

Style

Trends

Inspiration

Textiles

Notes

Swatches

Details

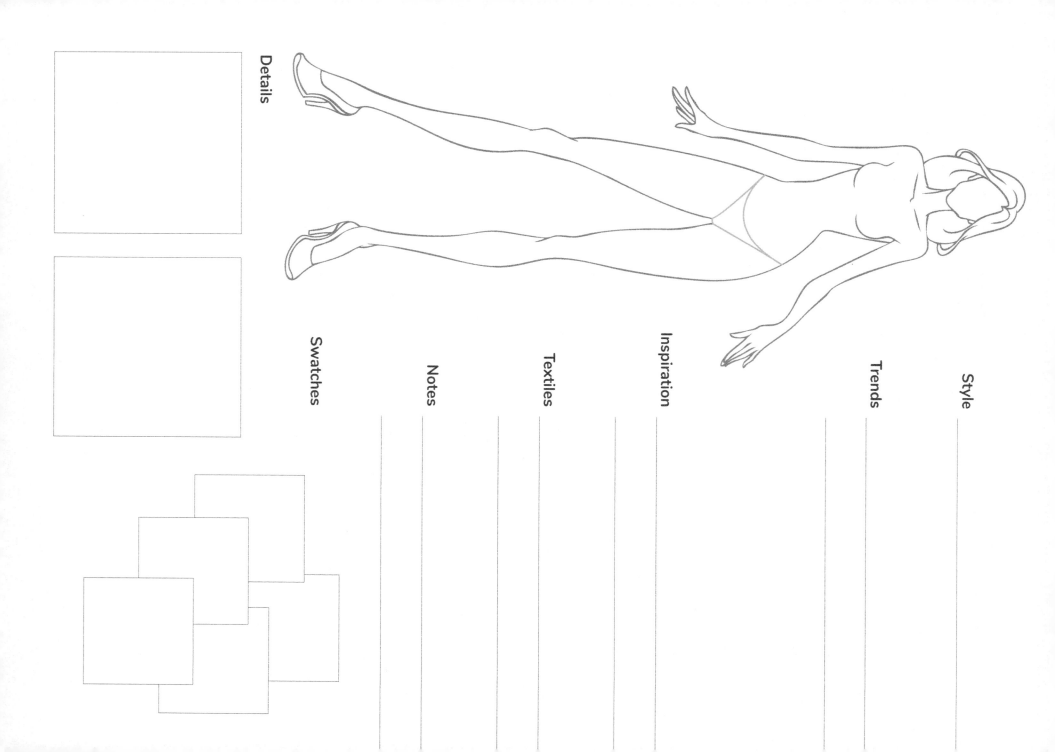

Details

Style

Trends

Inspiration

Textiles

Notes

Swatches

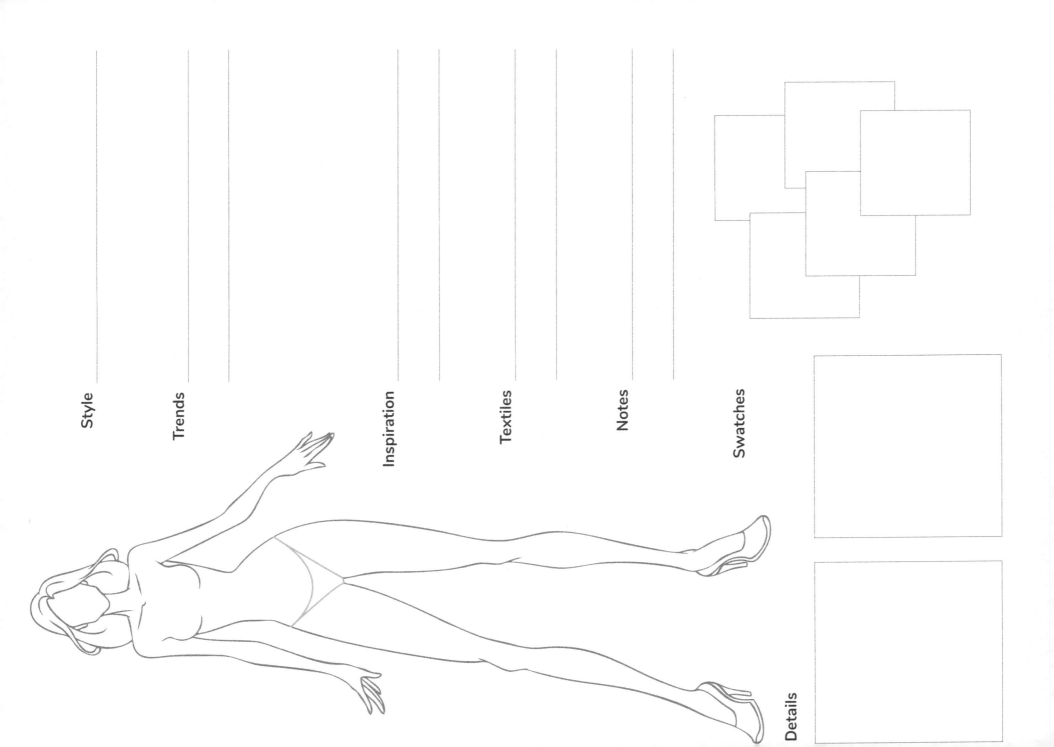

Style

Trends

Inspiration

Textiles

Notes

Swatches

Details

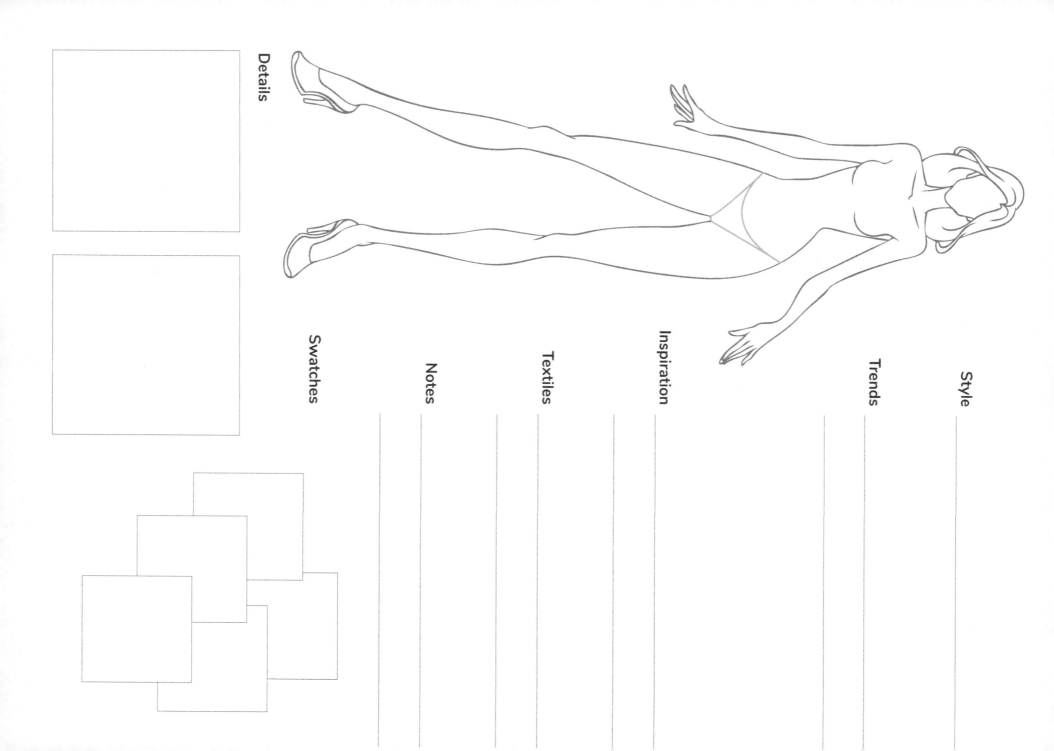

Details

Style

Trends

Inspiration

Textiles

Notes

Swatches

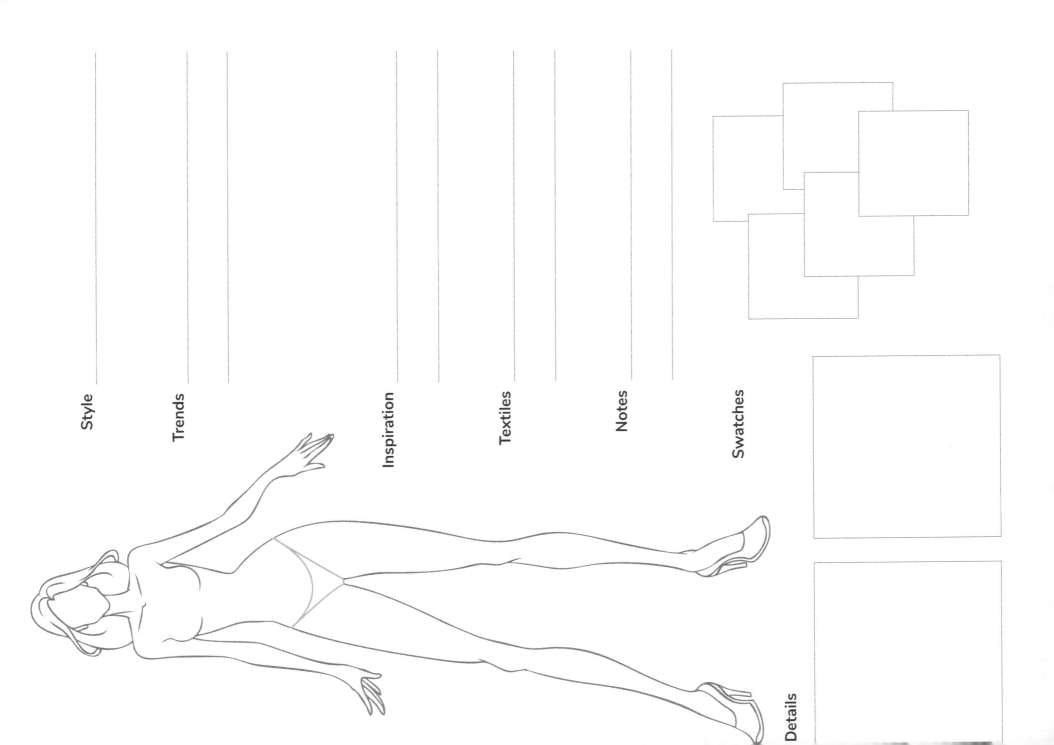

Style

Trends

Inspiration

Textiles

Notes

Swatches

Details

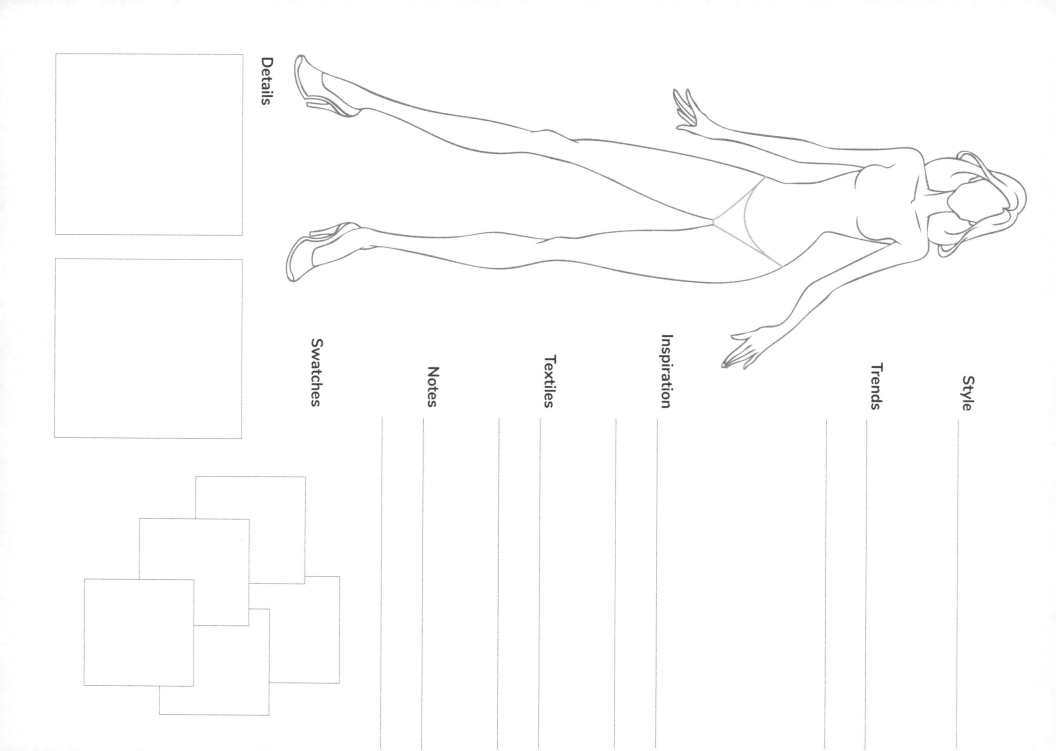

Details

Style

Trends

Inspiration

Textiles

Notes

Swatches

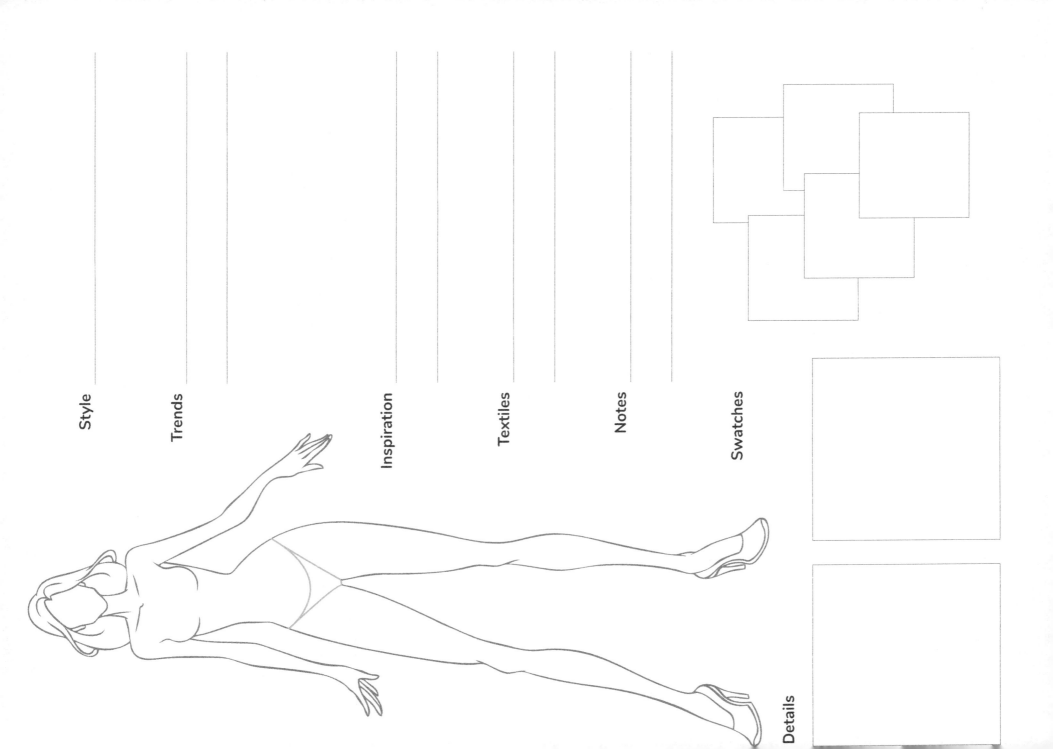

Style

Trends

Inspiration

Textiles

Notes

Swatches

Details

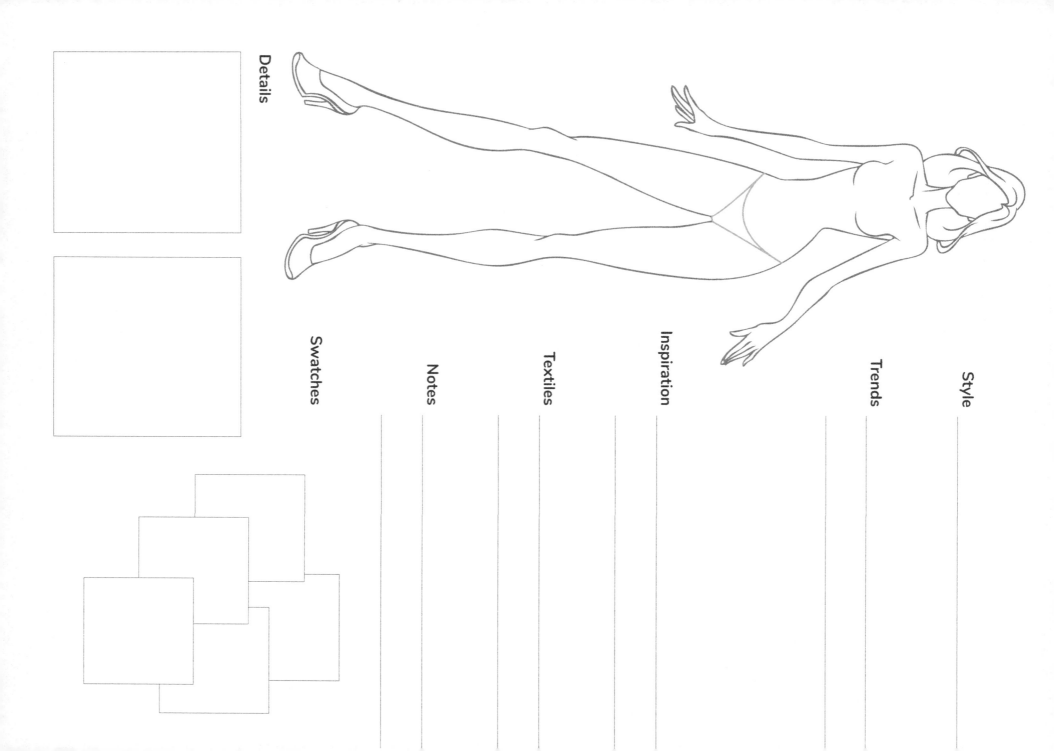

Details

Swatches

Notes

Textiles

Inspiration

Trends

Style

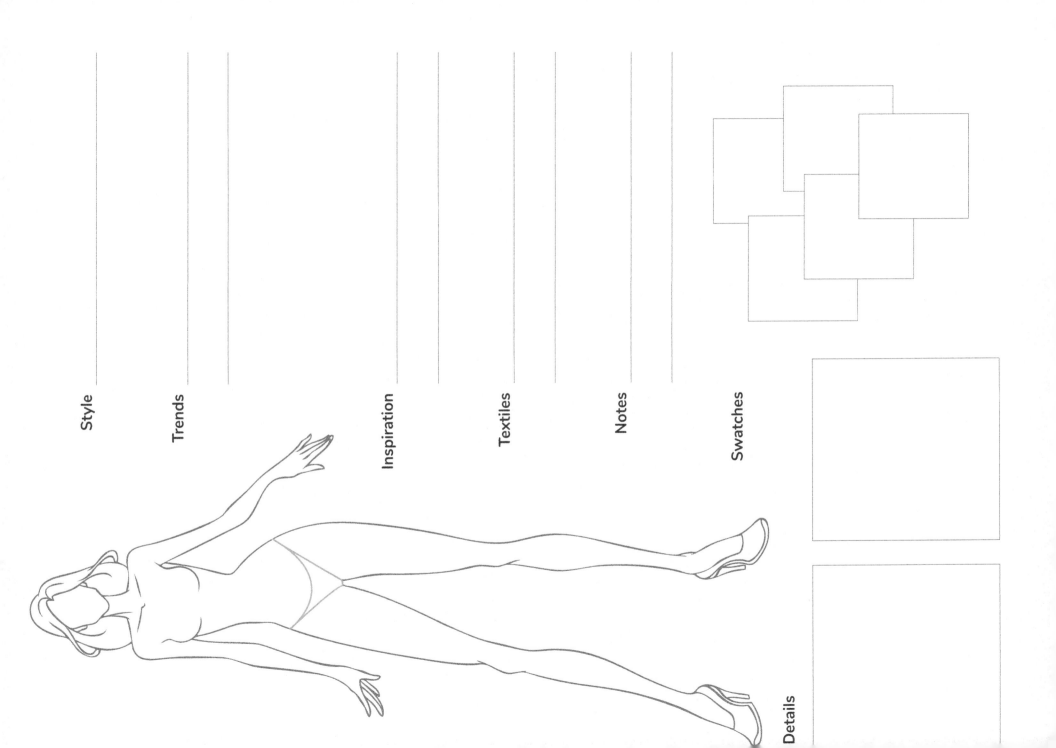

Style

Trends

Inspiration

Textiles

Notes

Swatches

Details

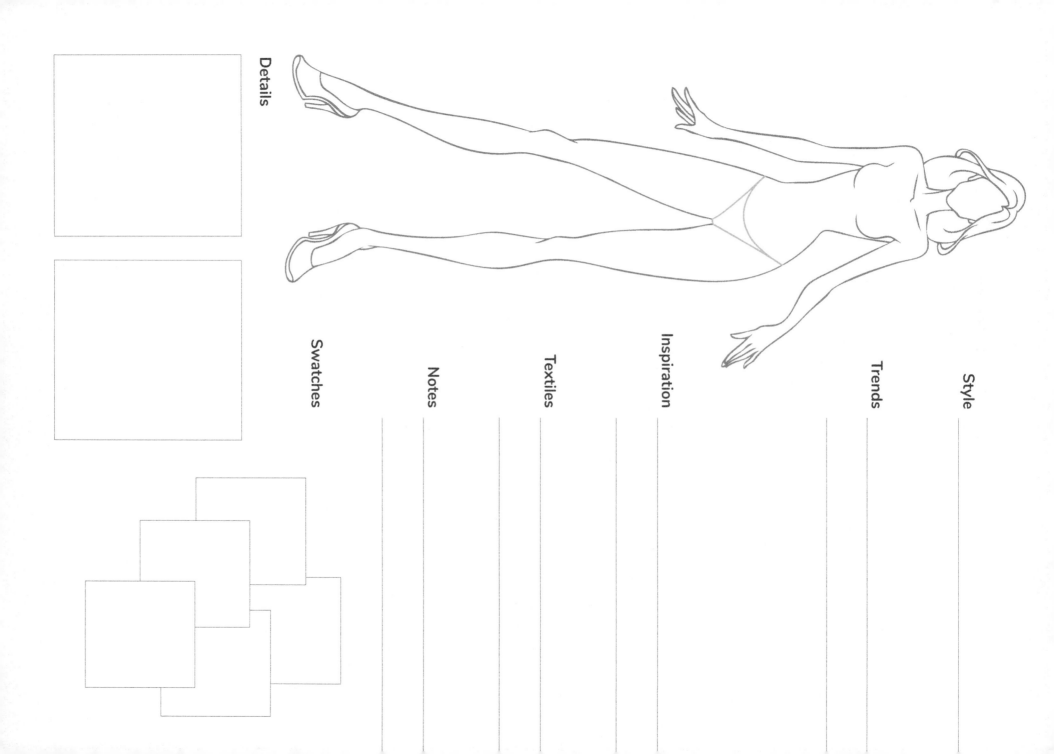

Details

Style

Trends

Inspiration

Textiles

Notes

Swatches

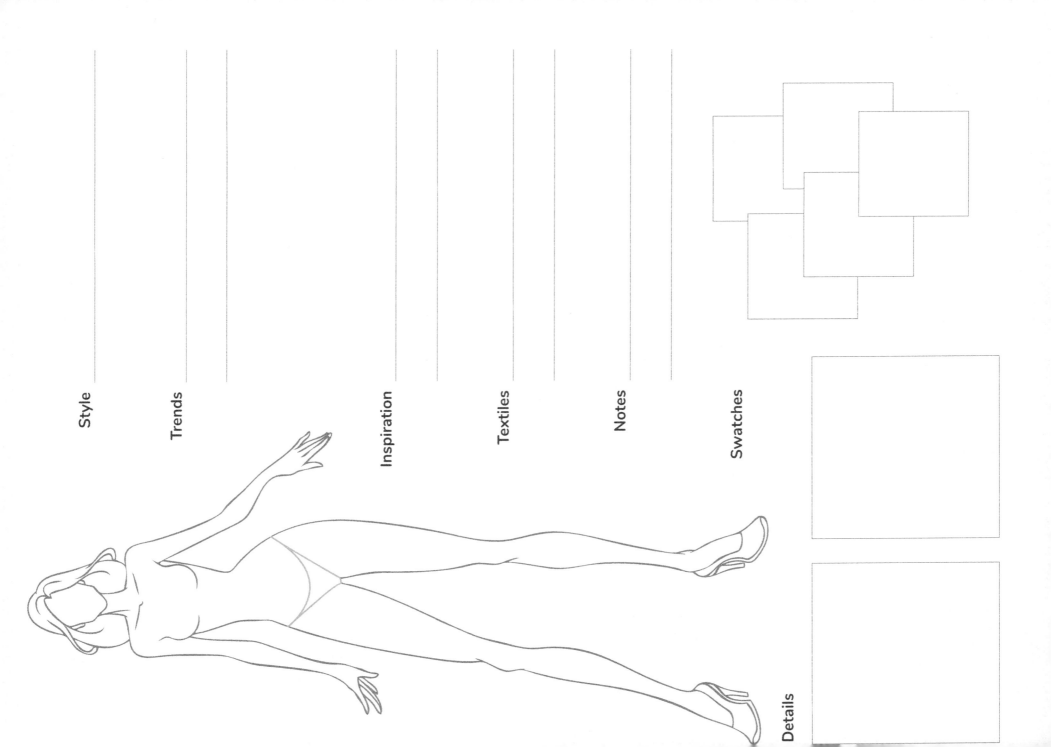

Style

Trends

Inspiration

Textiles

Notes

Swatches

Details

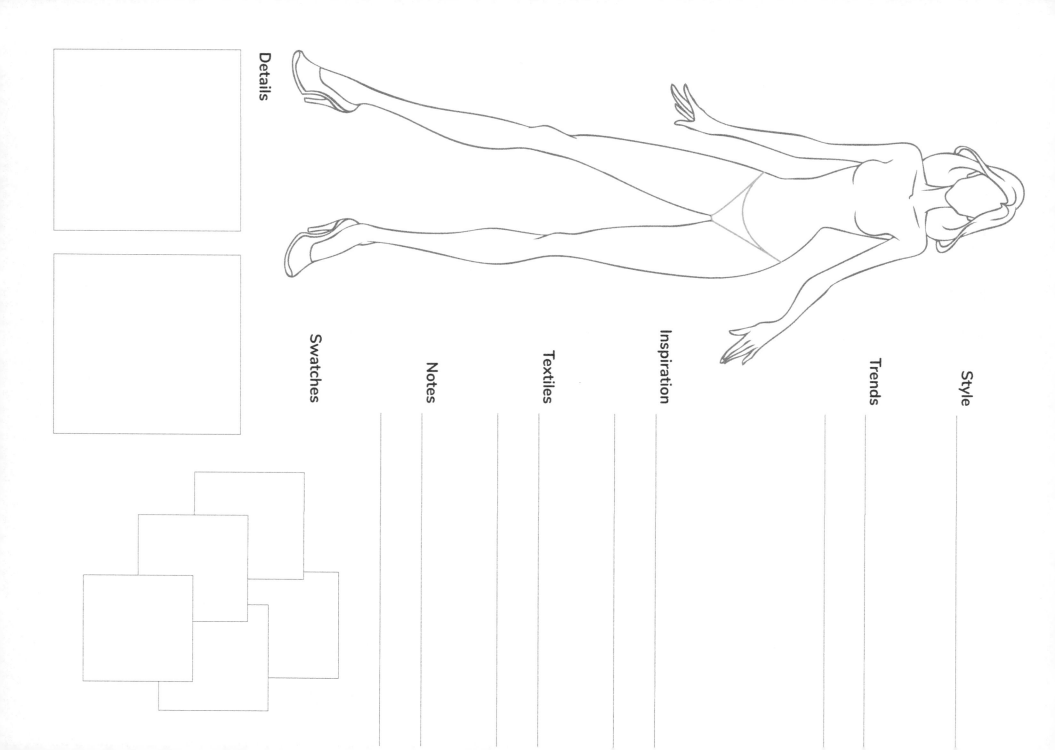

Details

Style

Trends

Inspiration

Textiles

Notes

Swatches

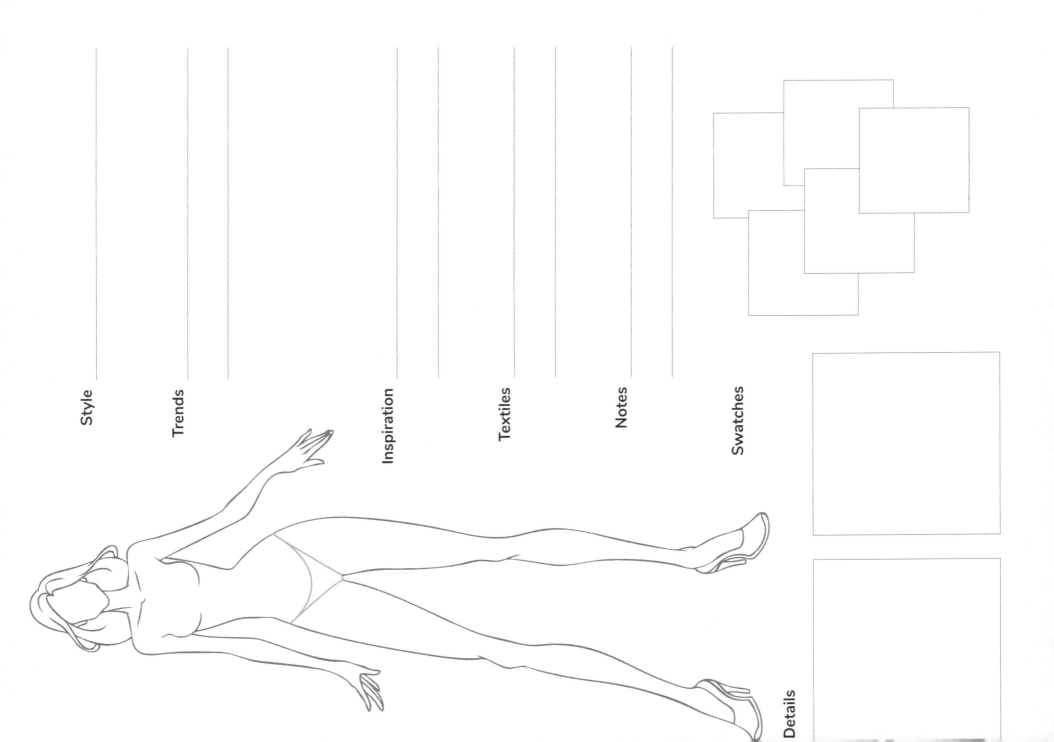

Style

Trends

Inspiration

Textiles

Notes

Swatches

Details

Details

Swatches

Notes

Textiles

Inspiration

Trends

Style

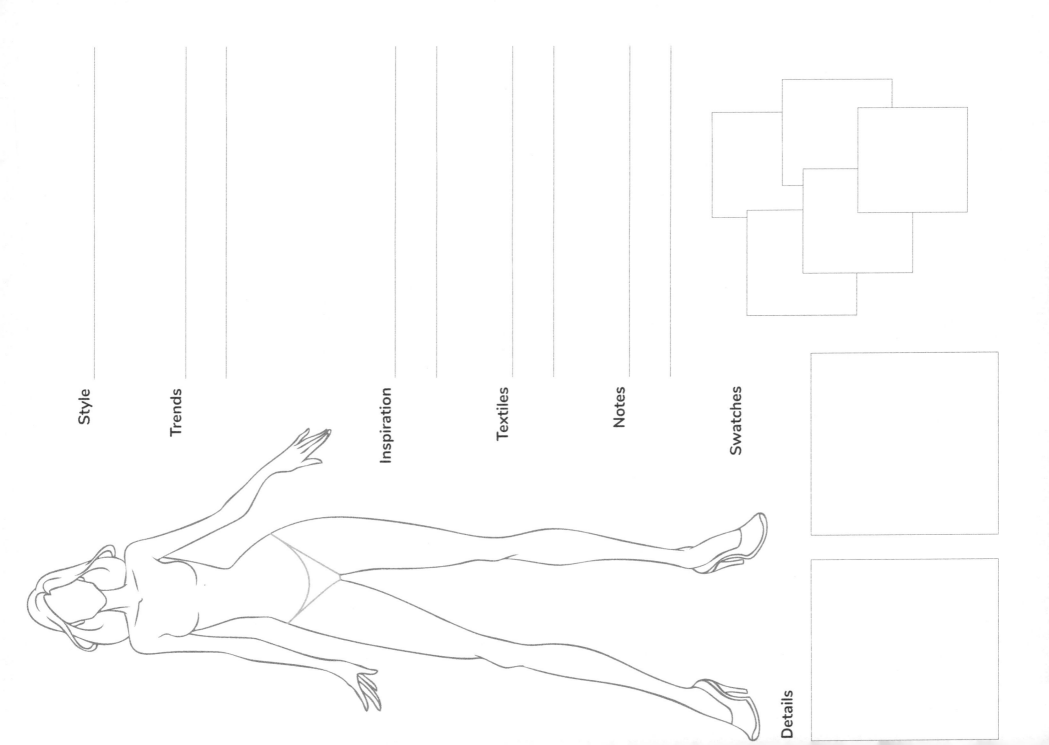

Style

Trends

Inspiration

Textiles

Notes

Swatches

Details

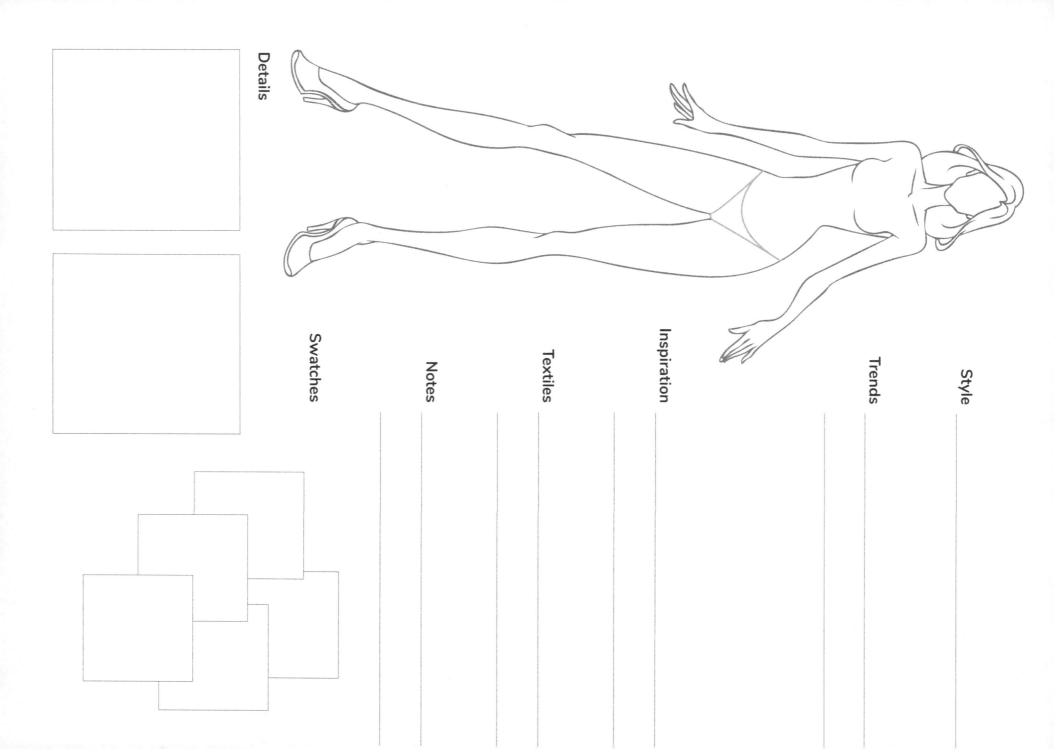

Details

Style

Trends

Inspiration

Textiles

Notes

Swatches

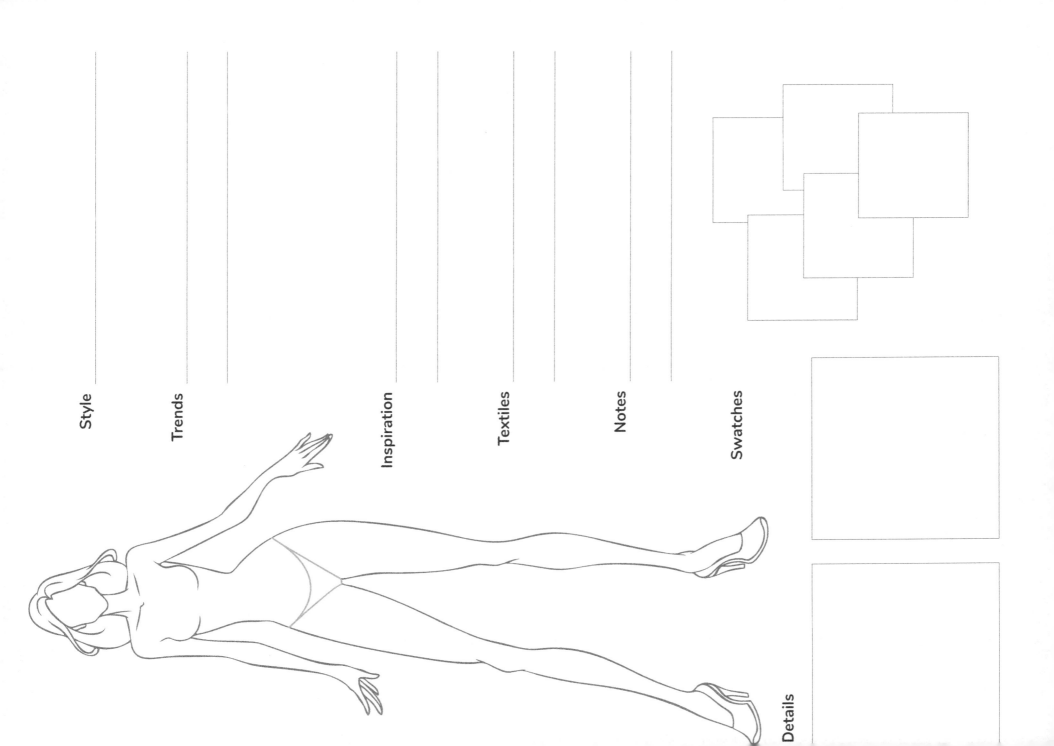

Style

Trends

Inspiration

Textiles

Notes

Swatches

Details

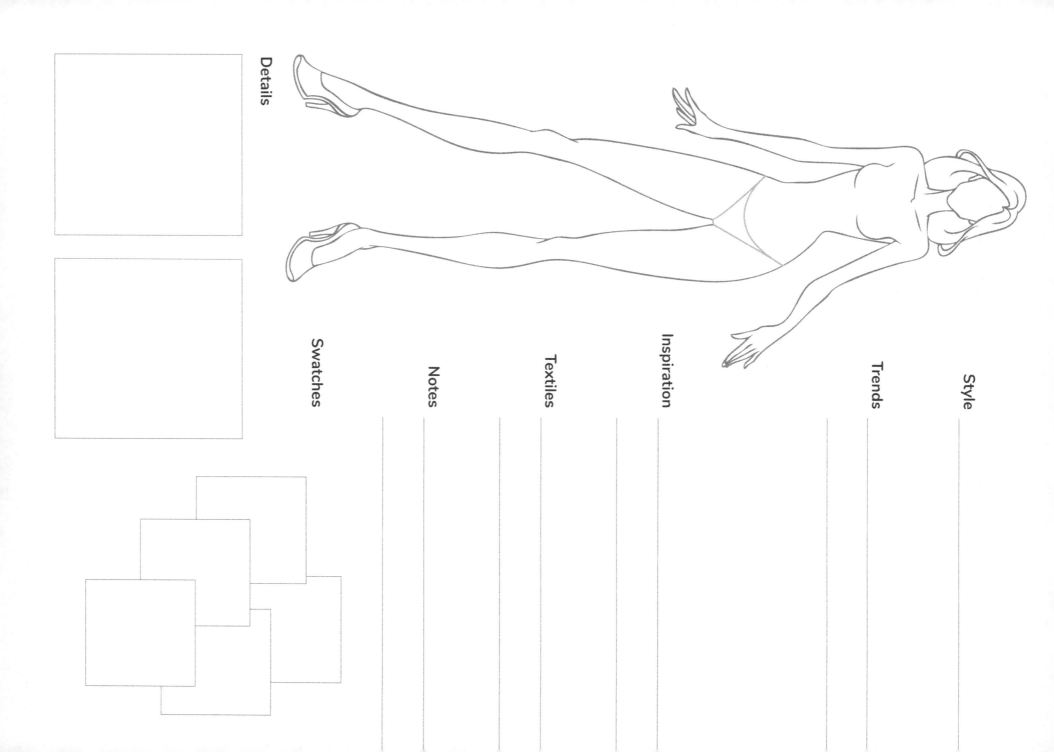

Details

Swatches

Notes

Textiles

Inspiration

Trends

Style

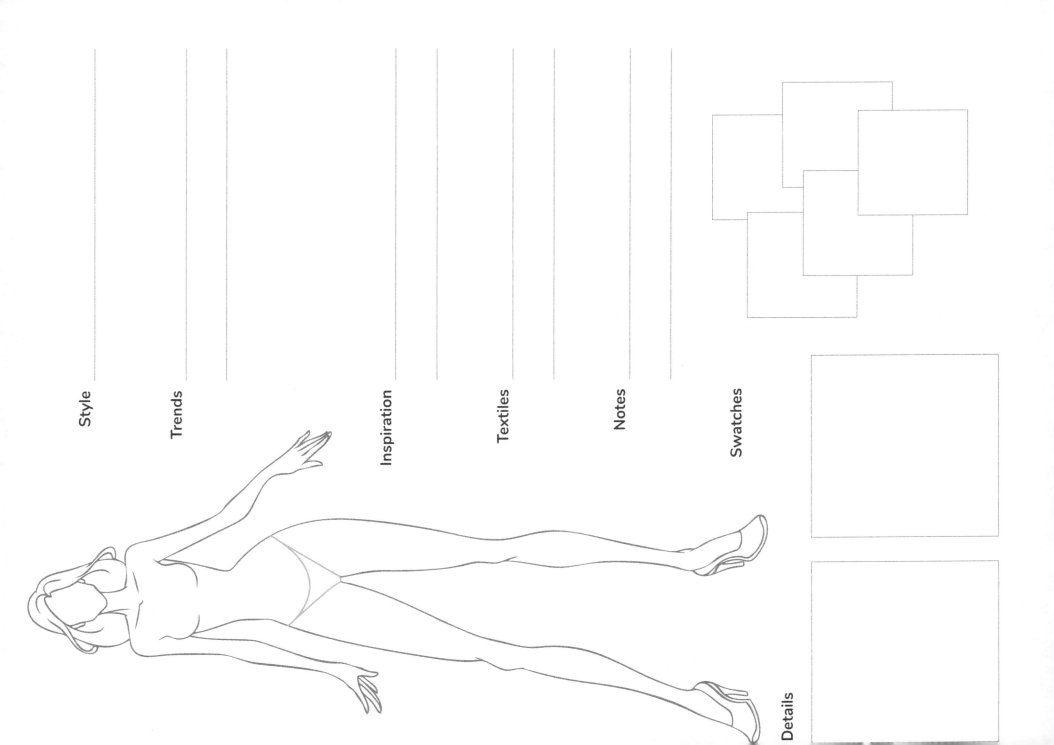

Style

Trends

Inspiration

Textiles

Notes

Swatches

Details

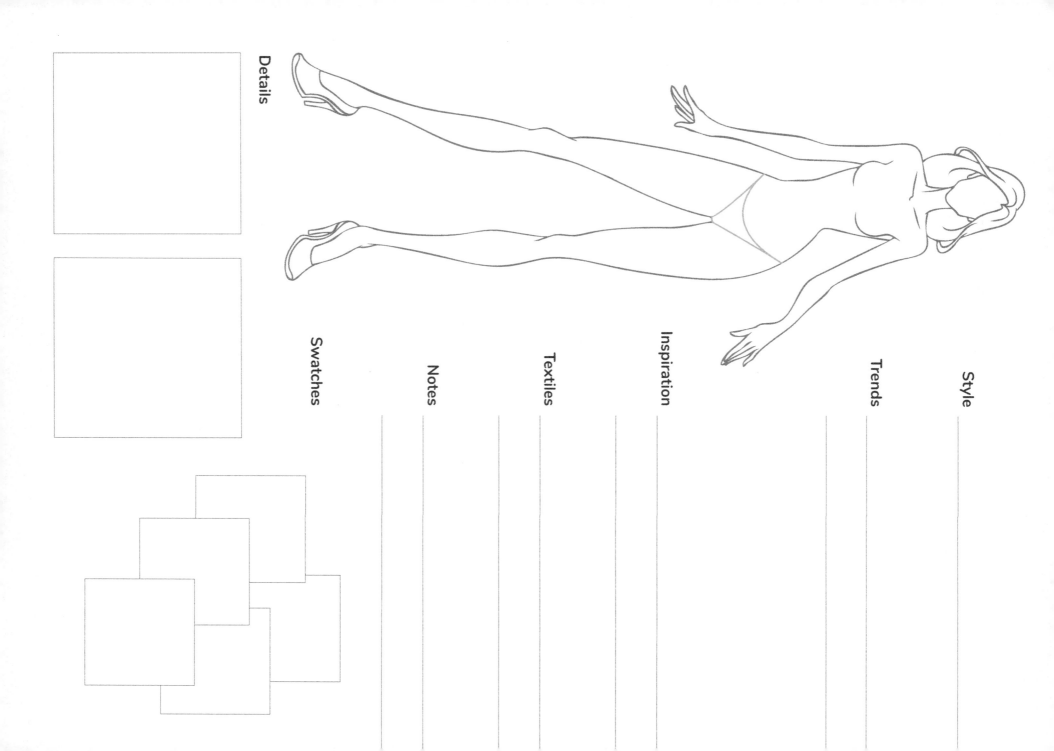

Details

Style

Swatches

Notes

Textiles

Inspiration

Trends

Style

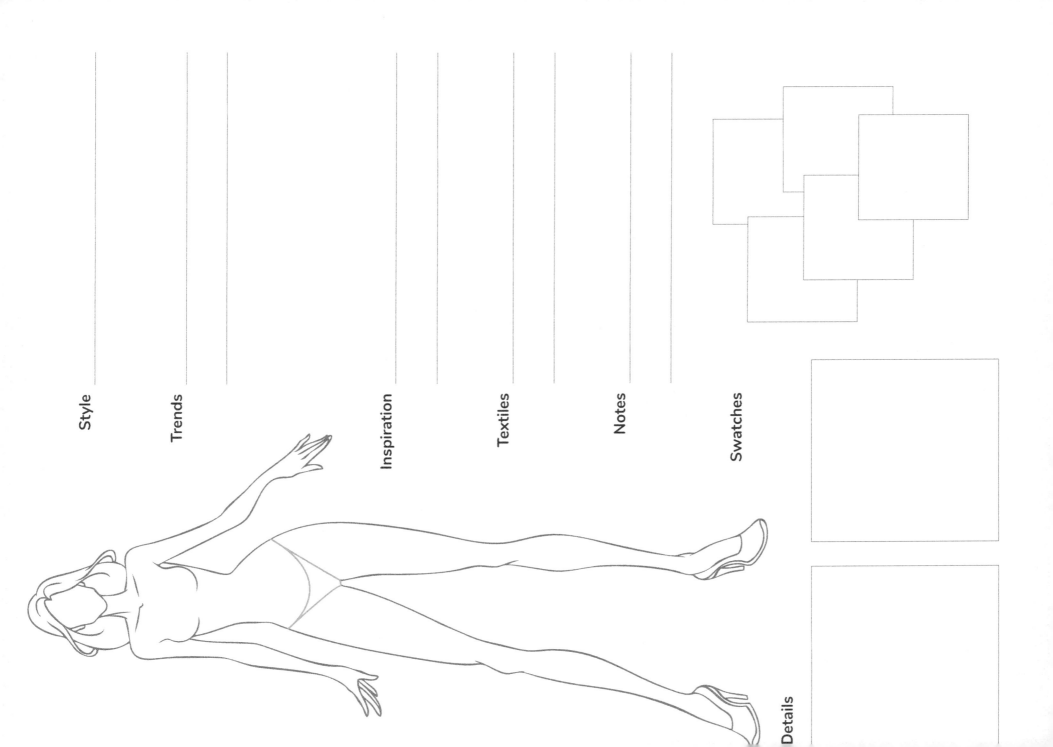

Style

Trends

Inspiration

Textiles

Notes

Swatches

Details

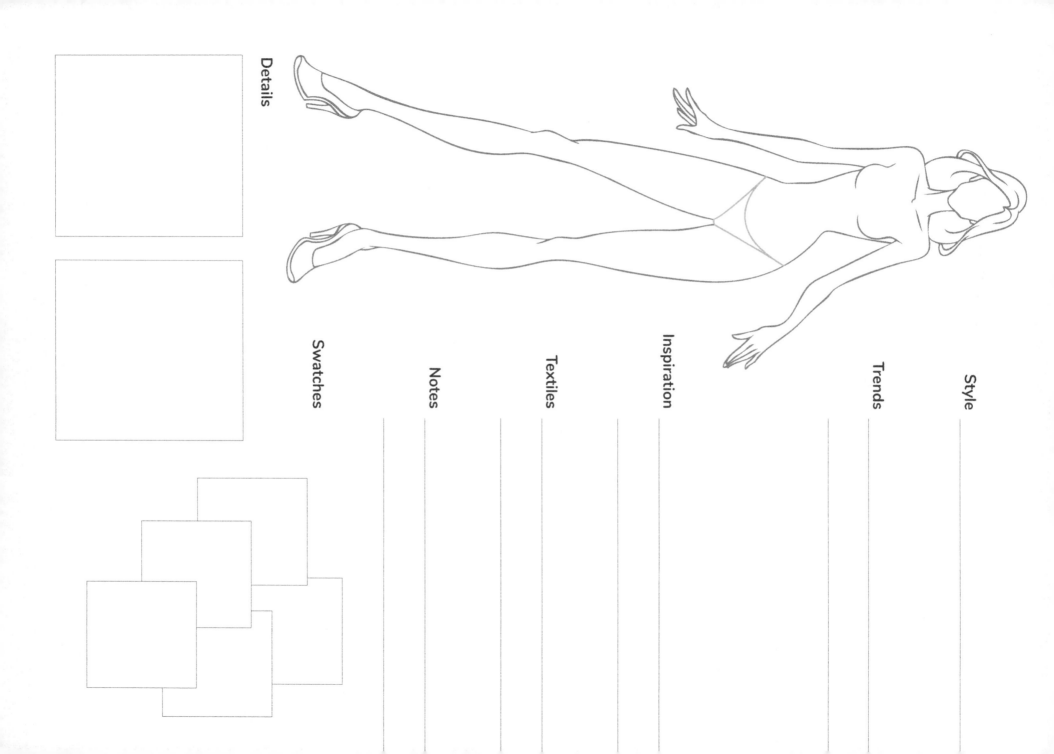

Details

Style

Trends

Inspiration

Textiles

Notes

Swatches

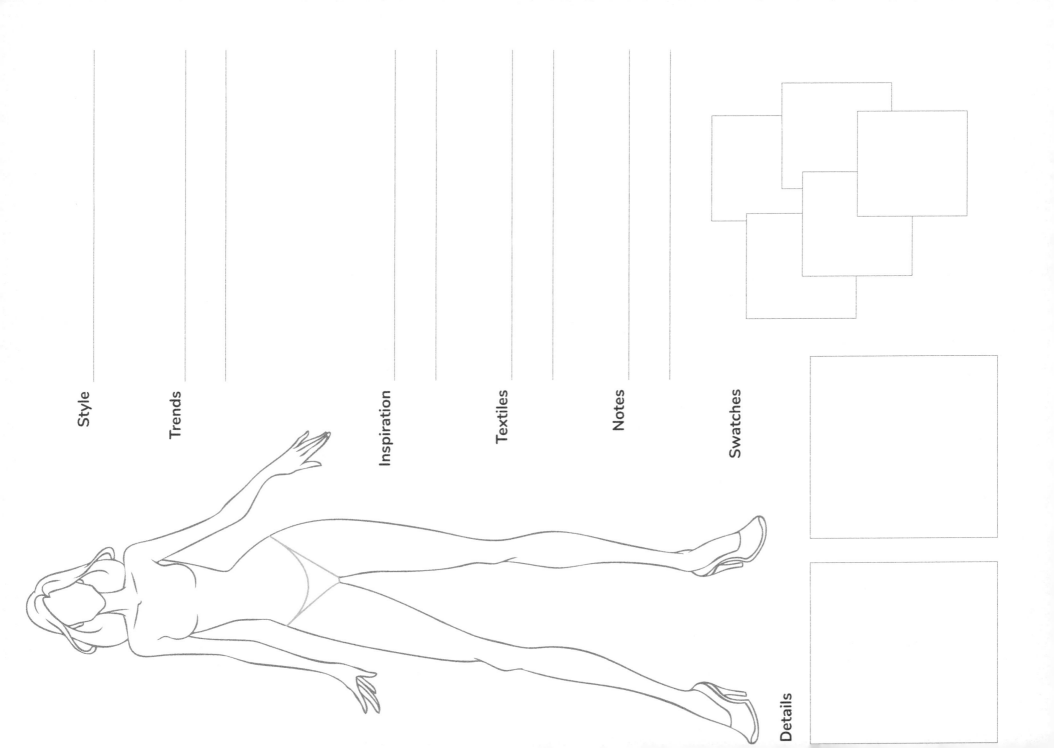

Style

Trends

Inspiration

Textiles

Notes

Swatches

Details

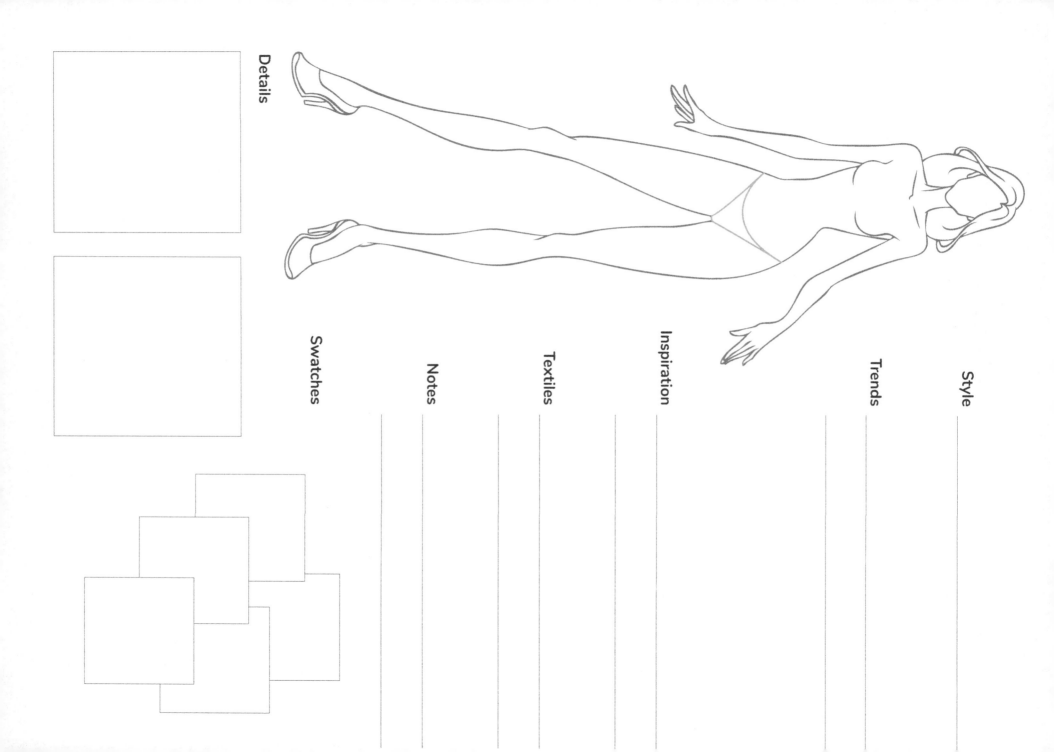

Details

Style

Trends

Inspiration

Textiles

Notes

Swatches

Style

Trends

Inspiration

Textiles

Notes

Swatches

Details

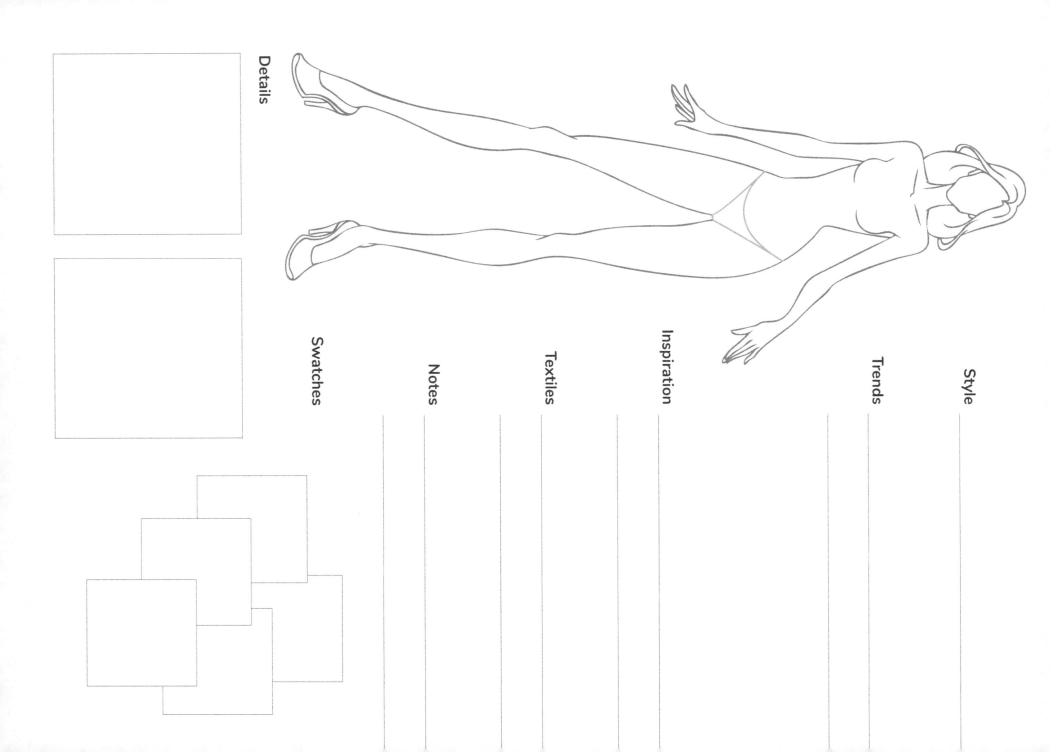

Details

Style

Trends

Inspiration

Textiles

Notes

Swatches

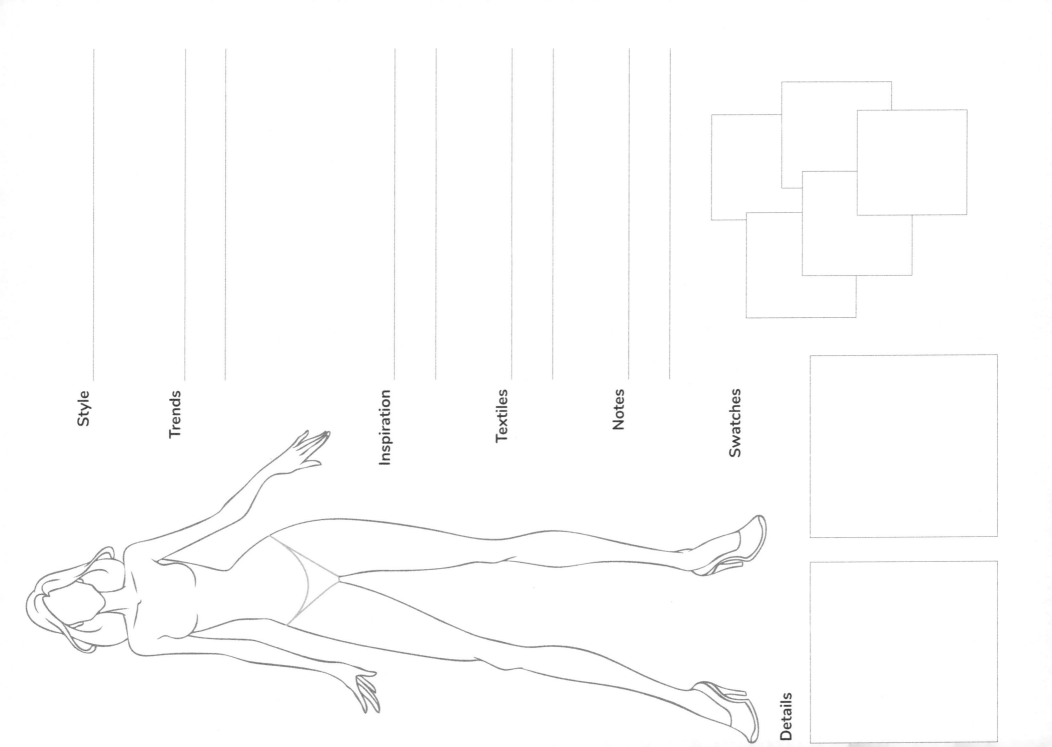

Style

Trends

Inspiration

Textiles

Notes

Swatches

Details

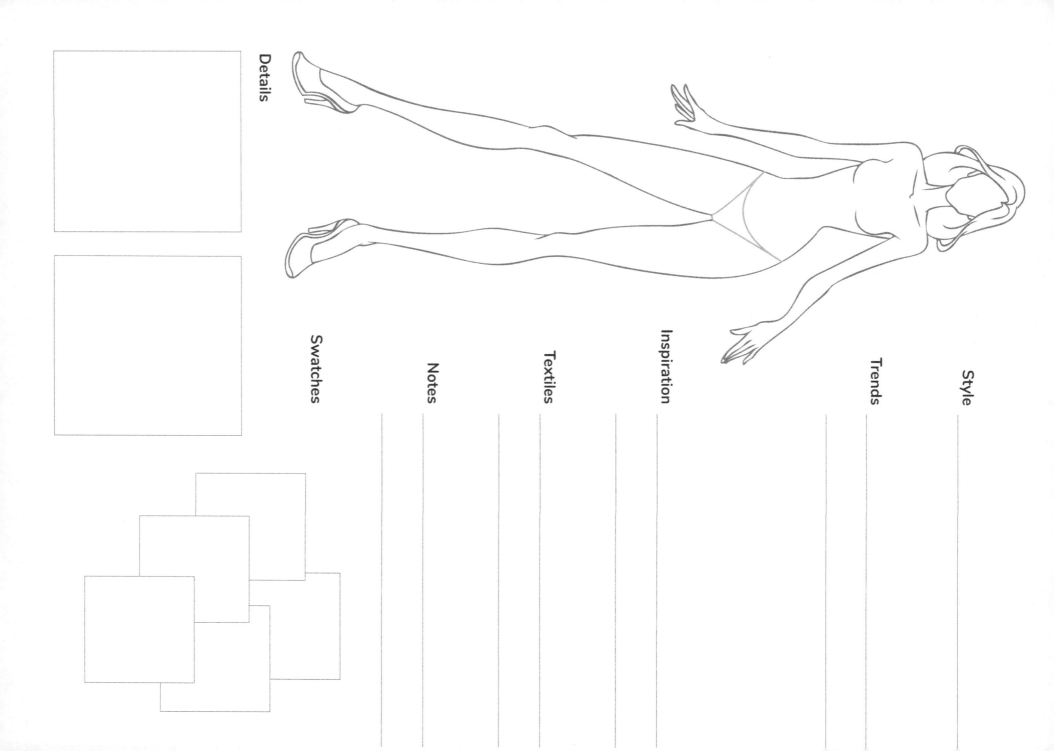

Details

Style

Trends

Inspiration

Textiles

Notes

Swatches

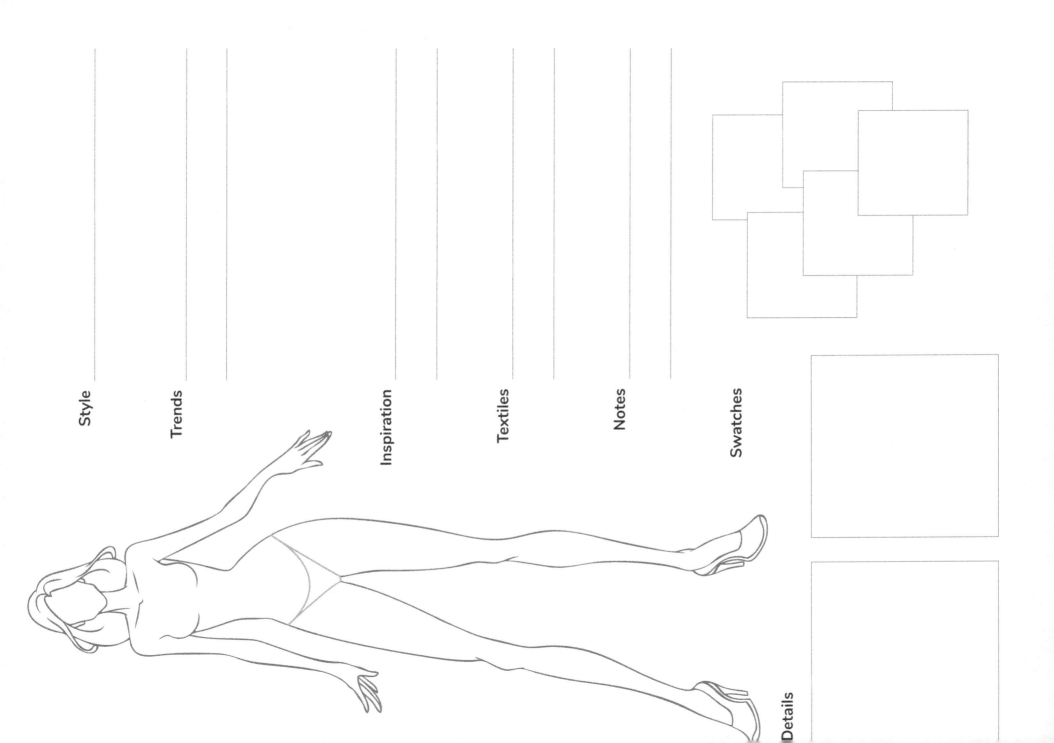

Style

Trends

Inspiration

Textiles

Notes

Swatches

Details

Details

Swatches

Notes

Textiles

Inspiration

Trends

Style

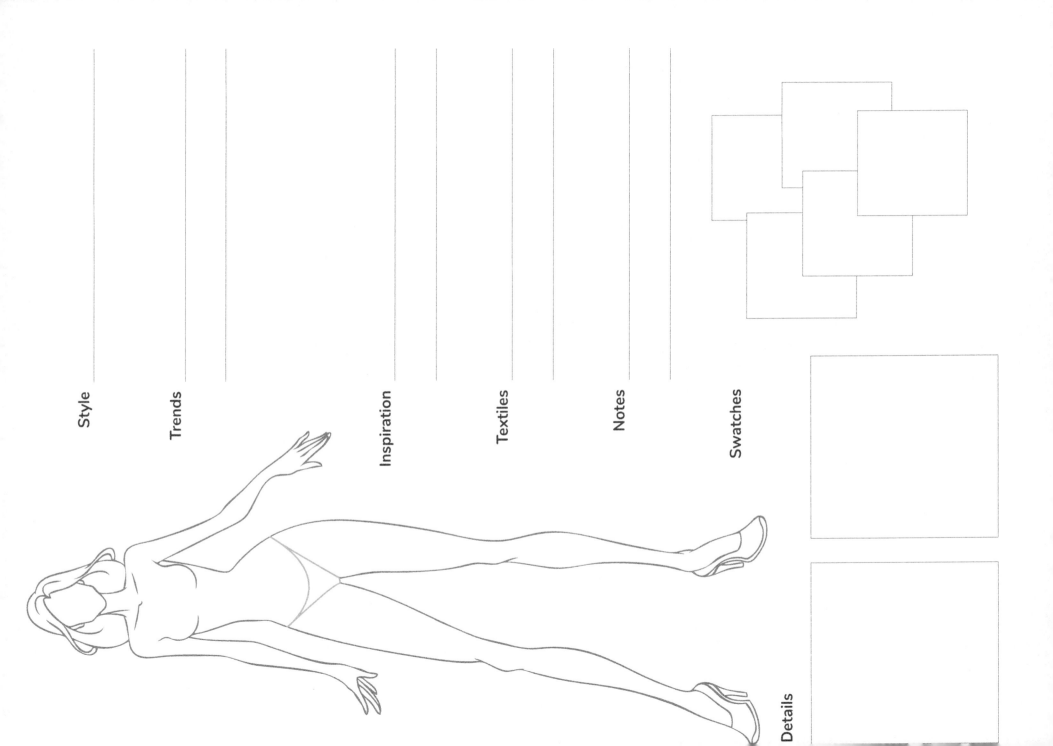

Style

Trends

Inspiration

Textiles

Notes

Swatches

Details

Details

Swatches

Notes

Textiles

Inspiration

Trends

Style

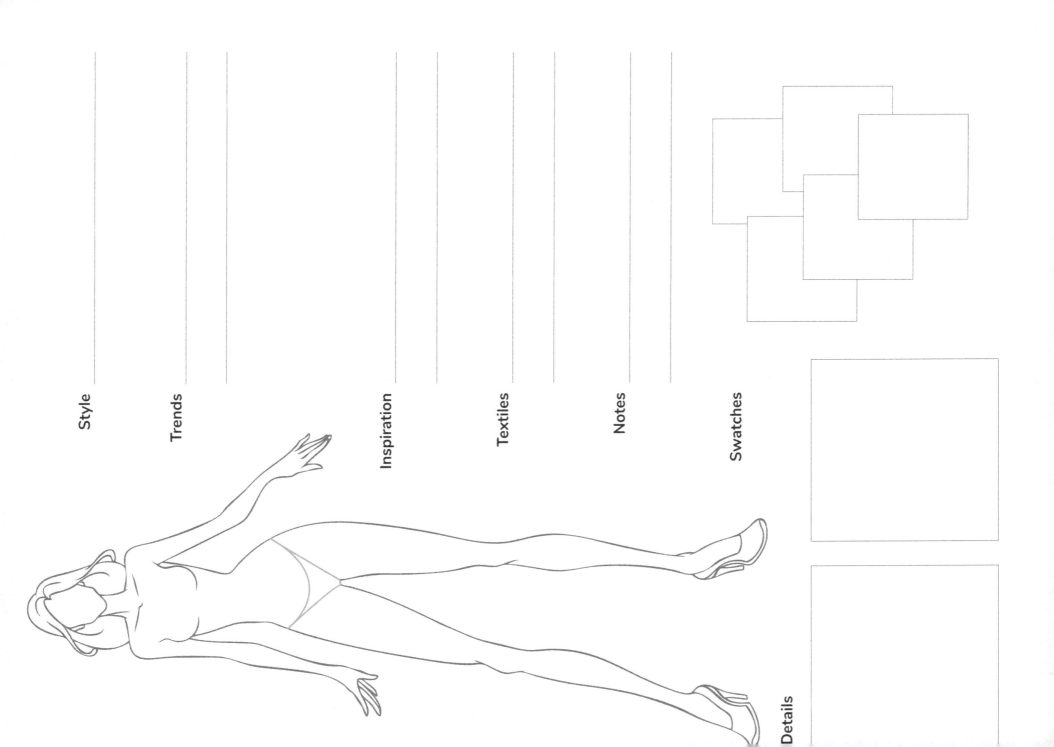

Style

Trends

Inspiration

Textiles

Notes

Swatches

Details

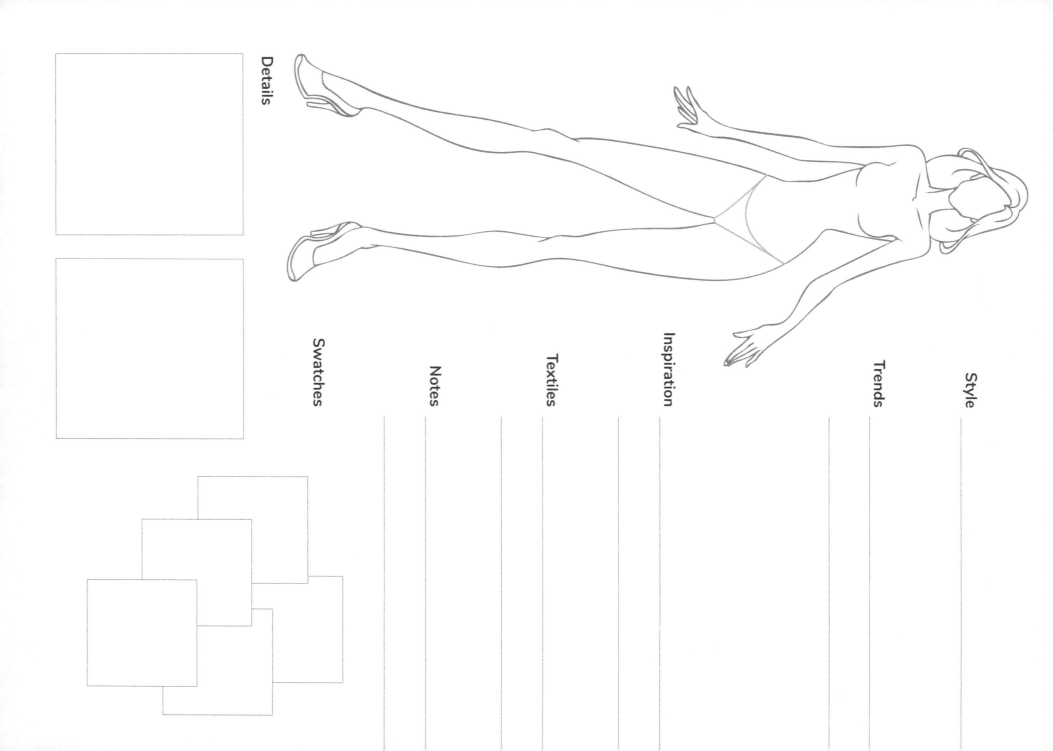

Details

Swatches

Notes

Textiles

Inspiration

Trends

Style

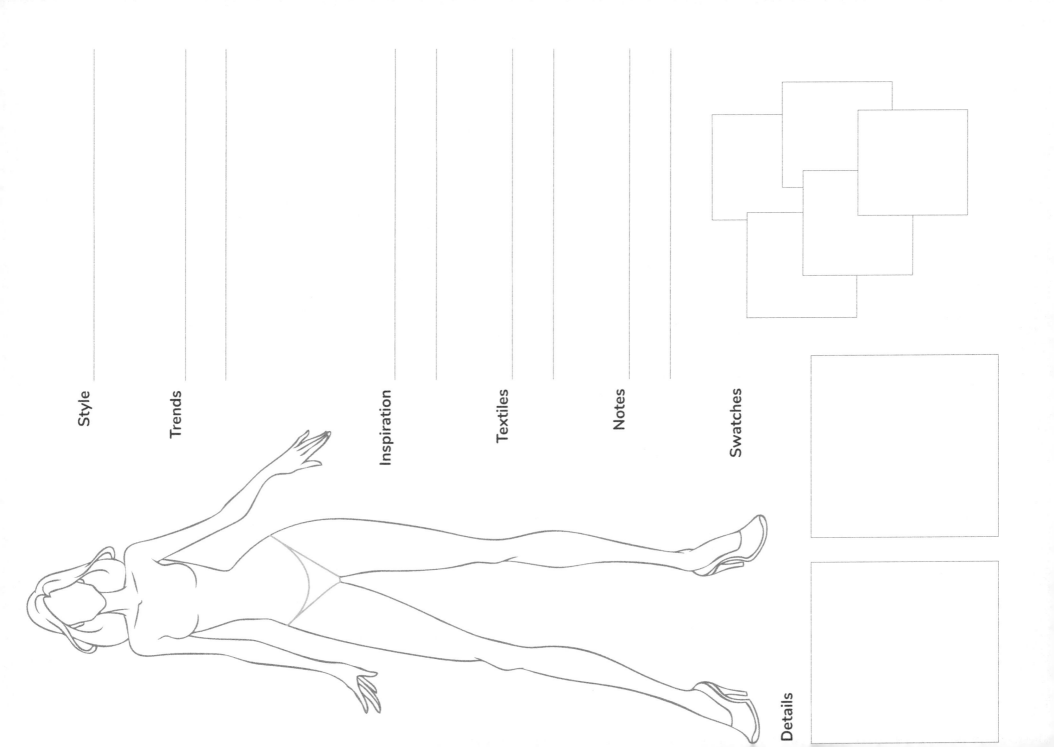

Style

Trends

Inspiration

Textiles

Notes

Swatches

Details

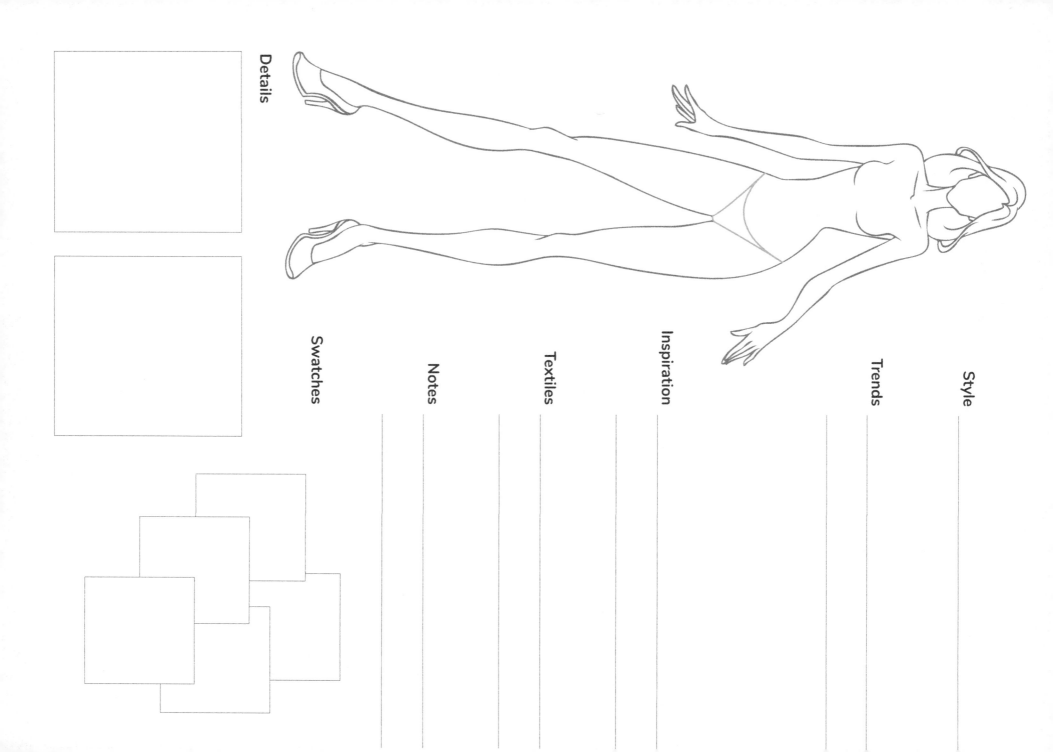

Details

Swatches

Notes

Textiles

Inspiration

Trends

Style

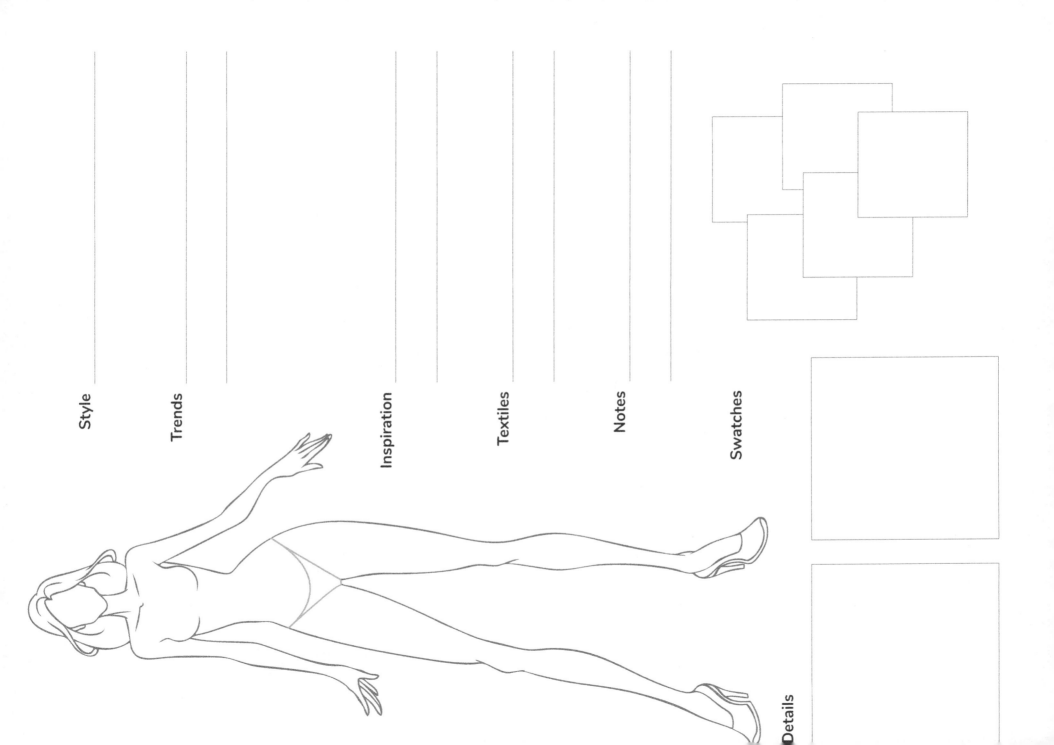

Style

Trends

Inspiration

Textiles

Notes

Swatches

Details

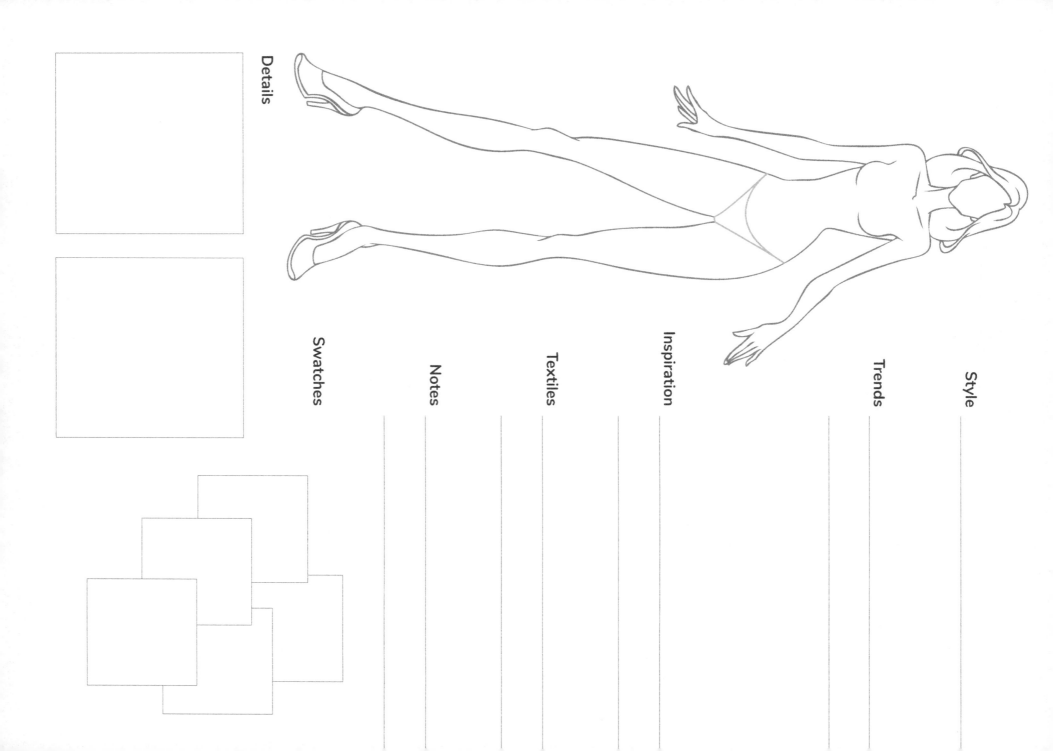

Details

Style

Trends

Inspiration

Textiles

Notes

Swatches

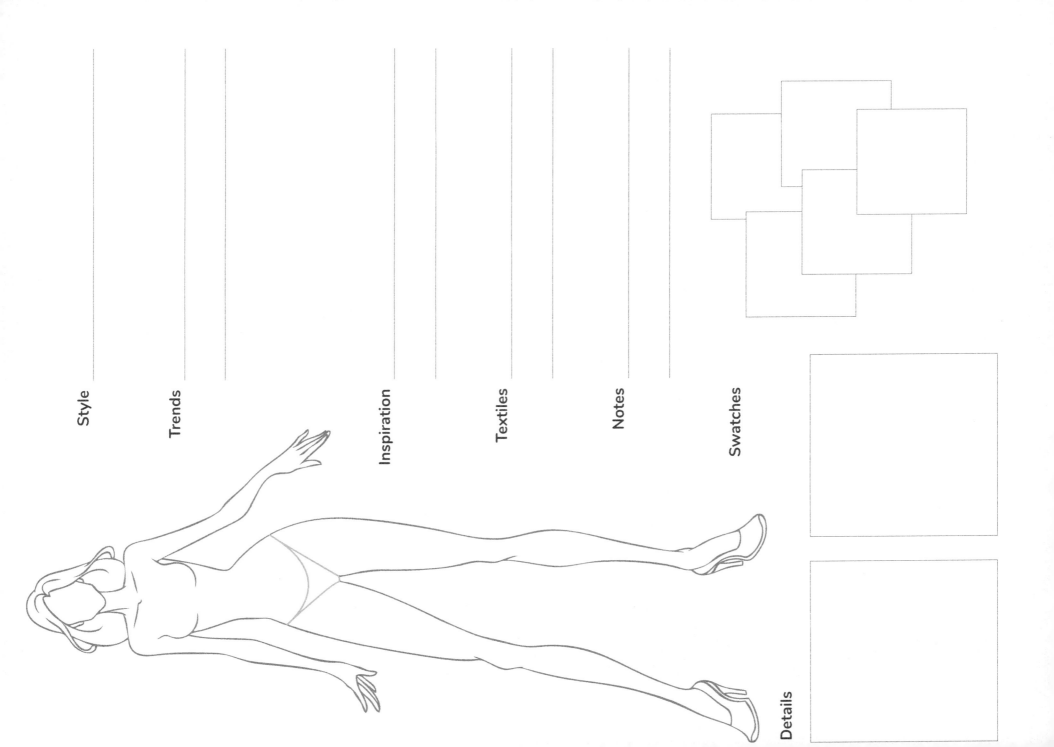

Style

Trends

Inspiration

Textiles

Notes

Swatches

Details

Made in the USA
Las Vegas, NV
24 July 2021